DRAWING WITH MARKERS

DRAWING WITH MARKERS

BY RICHARD WELLING

WATSON-GUPTILL PUBLICATIONS, NEW YORK

PITMAN PUBLISHING, LONDON

Copyright © 1974 by Watson-Guptill Publications
First published 1974 in the United States and Canada by Watson-Guptill Publications,
a division of Billboard Publications, Inc.,
One Astor Plaza, New York, N.Y. 10036
Published simultaneously in Great Britain by Sir Isaac Pitman & Sons Ltd.,
39 Parker Street, Kingsway, London WC2B 5 PB
ISBN 0–273–00807–2

Manufactured in the U.S.A.
Library of Congress Cataloging in Publication Data
Welling, Richard, 1926–
 Drawing with markers.
 Bibliography: p.
 1. Pen drawing. I. Title.
NC905.W44 741.2′6 73–20202
ISBN 0–8230–1462–2
First Printing, 1974

To Jane Louise with love

ACKNOWLEDGMENTS

To my daughter Debrah for being such a good sport during our vacation trip to Maine. A special thanks to Denise McGovern for being such a willing model. To well-known Hartford painter Irving Katzenstein for many fine talks about drawing and for pointing out to me that there is a picture everywhere you look. I put that to good use for some of the illustrations in this book. And finally, super thanks to Margit Malmstrom of Watson-Guptill for her splendid editorial help.

CONTENTS

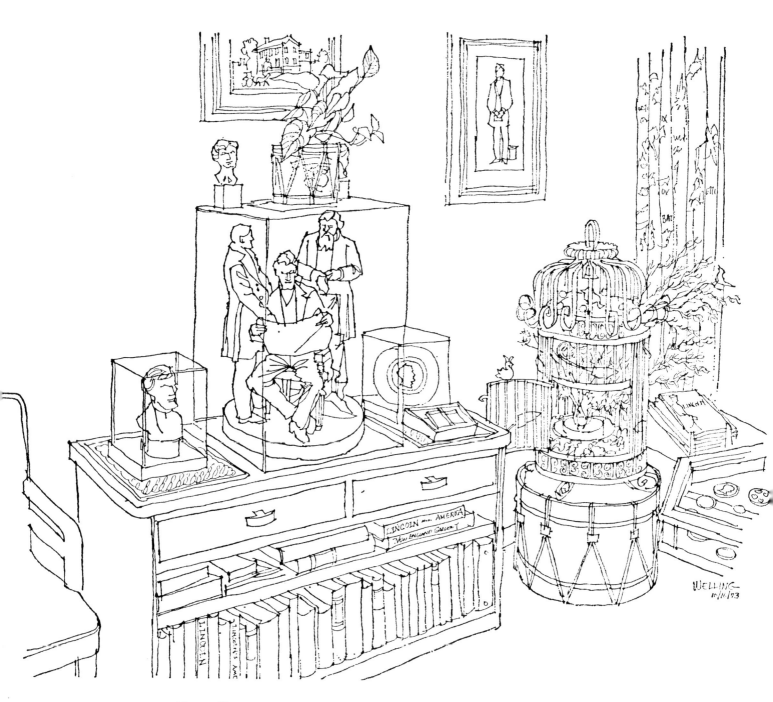

Mr. Kofsky's Office. *Pentel on 14" × 17" textured paper. Mr. Kofsky asked me to draw a section of his office, and this delightful sketch, drawn directly in Pentel from a standing position, is the result. As soon as I got a good likeness of the Lincoln group in the middle, I knew my sketch would be a success.*

INTRODUCTION

If you're anything like me, when a new drawing book catches your eye you pick it up and leaf through it looking at the illustrations. If they appeal to you enough, you buy the book and add it to your collection of artbooks. For me, the criteria for a good drawing book are good drawings and interesting subject matter. I believe, and I hope that you'll agree with me, that you'll find both in the following pages.

Although there are really no hard and fast rules in drawing, I have tried to pass on a few pointers, especially in terms of approach: materials, how to begin, how to use a wide variety of techniques. You'll find that the step-by-step demonstrations illustrate many different techniques, all of which you should try and experiment with. If you're a novice at using markers, pick up a few fine-line Pentels and a few wide-tip markers and draw your favorite subject over and over again in all the techniques demonstrated. You'll soon find yourself creating drawings that please you. You'll also find, as I have, that the versatility of markers is limited only by the artist's imagination.

I suppose the purpose, and the message, of this book could be summed up very simply: I love to draw! And I want to infect you with the same enthusiasm. So as you read and as you follow the demonstrations, remember that the only "secret" to good drawing is just that: draw, draw, and draw!

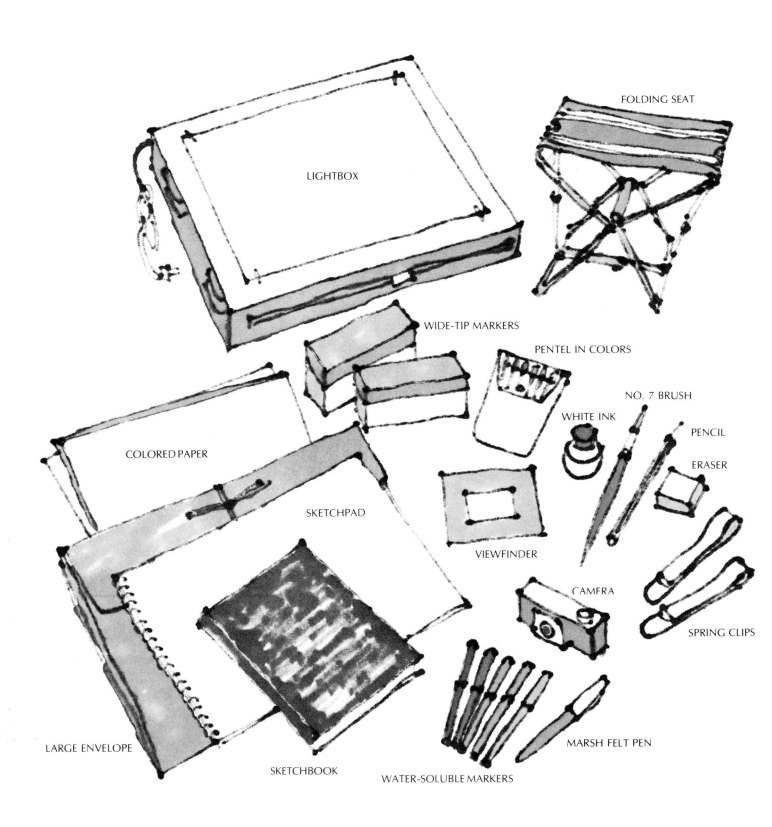

LIGHTBOX

FOLDING SEAT

WIDE-TIP MARKERS

PENTEL IN COLORS

NO. 7 BRUSH

PENCIL

ERASER

WHITE INK

COLORED PAPER

SKETCHPAD

VIEWFINDER

SPRING CLIPS

CAMERA

LARGE ENVELOPE

SKETCHBOOK

WATER-SOLUBLE MARKERS

MARSH FELT PEN

The materials you will need for drawing with markers are shown above.

1
MATERIALS

The following list of supplies has suited me admirably for all my drawing assignments both in the studio and on location.

Please remember that you don't need all these supplies to get yourself started drawing with markers: a few fine-line Pentels, a few values of gray in the wide-tip felt pen, and a 14″ × 17″ sketchpad, and you're in business!

This is the beauty of drawing with markers: you can take as much or as little as you want along with you and still have fun drawing!

WIDE-TIP FELT MARKERS

There are numerous excellent brands of wide-tip felt markers available. Two well-known brands for drawing purposes are Magic Markers, which come in the form of small, easy-to-hold glass vials, and Eagle Prismacolor markers, which are styled along the line of fat pencils. Either one of these is convenient to carry and use. The tip of wide-tip markers is about ¼″ wide and beveled slightly to make it easy for you to lay in a tone.

The popularity of markers is evident in the wide range of colors now available—literally hundreds! A selection of basic hues is adequate for most color effects, but should you require an off-beat color now and then, chances are it's available.

Markers also come in warm and cool grays of different values, which are splendid when you don't want to work in color but still want to capture the tonal nuances of your subject.

If you leave a marker uncapped for a long period of time, say overnight, it will dry out. Try to get in the habit of capping each color the minute you're through using it.

FINE-LINE MARKERS

The Pentel fine-line marker is one of the best for drawing in the traditional pen and ink manner. Traditional, that is, except that you are not using a metal pen point, nor do you have to keep dipping into an ink bottle.

Fine-line markers have a small-diameter felt tip that comes to a nice point, and the ink supply is such that you can complete quite a few drawings before it runs out.

You can vary the quality of your line by the amount of pressure you apply as you draw. The more pressure, the heavier the line. But, since the tip is made of felt, it will eventually become blunt with wear and lose its ability to create fine lines. When this happens, discard it and buy a new one.

Pentels come in about a dozen basic colors and are good for quick, lively color notes. Black Pentel is water-soluble, allowing you to create wash effects by simply brushing clear water over your sketch. (More about this in Chapter 3.)

There are also other water-soluble fine-line markers available in colors, which will give you the opportunity to simulate watercolor effects.

Illustrator brand fine-line markers in three values of gray blend nicely with the warm gray wide-tip markers when you want to draw with a gray line instead of a black one.

Most of these fine-line markers will smudge slightly before they dry on your paper, and even after

they are dry, moisture from your hand can cause smudging. Be especially wary of this when out drawing on hot, humid days. Keep your drawing hand off the surface of your paper as much as possible.

MARSH FELT-TIP MARKER

This marker has interchangeable tips—round or chisel-point—and has a refillable felt cartridge inside that acts as an ink reservoir to feed ink to the felt tip. When the pen starts to run dry, simply take it apart and squirt some more ink onto the felt insert and you're ready to draw again.

The Marsh pen is nice for robust lines, and because the ink is very moist you can create reverse drawings with it when sketching on soft paper.

PAPER

The first and only rule (despise rules!) about paper is to be sure you have plenty on hand.

The spiral-bound sketchpad of 30 sheets is a convenient way to carry paper. Sizes vary from 7" × 10" up to 18" × 24". Aquabee and Strathmore have several good grades of paper in pad form.

Check with your local art supply store to see what they have on hand. Don't overburden yourself with too many brands. Find what's available in your area and to your liking and you're ready to do some drawing. (More about paper in Chapter 7.)

BOUND SKETCHBOOK

This differs from the spiral-bound sketchpad just mentioned in that it is an actual bound book of blank pages. Sizes range from 5" × 7" to 14" × 17" and consist of several hundred pages.

I like the 11" × 14" size. When opened flat it provides a 14" × 22" surface, which is a nice proportion for landscapes or cityscapes. The paper is very thin in bound sketchbooks and you'll find your markers bleeding through to the other side and perhaps even making a spot or two on the next page. To prevent spotting, it's advisable to slip a sheet of heavy paper under the page you're drawing on.

A great advantage of using a bound sketchbook is that you can draw in it and remain pretty much unobserved because it doesn't look like a sketchpad. It takes some practice to learn how to handle the gutter, or center of the book where the pages are bound. If you plan to use both pages, plan your composition so nothing too important has to be drawn across this dividing line.

FOLDING SEAT

This is a must when working on location. Made of heavy wire with a canvas seat, it folds flat for ease of carrying. You won't always be lucky enough to find a bench or pair of steps to sit on, so it's best to take your own seat.

TOTE BAG

This can be anything from an airline carryall bag to an attaché case. A large pocketbook will work, too.

LARGE ENVELOPE

A 19" × 25" expansible string-tied envelope is fine for carrying your paper supply and for stowing finished drawings. A folding seat will fit inside, too. It also offers protection for your work in case you get caught in a sudden downpour.

VIEWFINDER

A cardboard viewfinder is a big help in zeroing in on a composition. This is a piece of 5" × 6" cardboard with a 3" × 4" hole cut in it. The shape of this hole is the same proportion as most sketchpads, so whatever you see through the opening can be transferred to your paper in the same relationship.

Hold the viewfinder in front of one eye and move it in and out and to the left and right until you see a view that pleases you. Sketch in a few major shapes or forms and finish your drawing. The viewfinder is to help you train your eyes to see the important elements in your scene. After a while you won't need it at all.

CAMERA

The simpler the better! A Kodak Instamatic is fine for recording color and light patterns for future reference. Don't burden yourself with fancy photo equipment. Depend on your own eyes, not a f3.5 lens.

PENCIL AND ERASER

A soft No. 2 grade lead pencil is fine for laying in key areas and shapes before you use the markers. Use a light touch, so if you do have to erase you won't make grooves in your paper.

A kneaded eraser will remove your pencil lines without disturbing the surface of your paper too much.

BRUSH

A No. 7 round sable will be useful when you want to do wash effects with water-soluble markers. Get a fairly good one that comes to a nice point so you can control small areas of your wash.

SPRING CLIPS

Several steel-grip spring clips will help hold down the edges of your sketchpad as you draw. The large size works effectively on the thicker bound sketchbook.

WHITE INK

This is a very useful item to have in your tote bag in case you want to do some lettering or add lights to a night scene. Artone white ink can be used full strength or diluted with water for tint effects.

FLO-MASTER CLEANSER

This fluid will clean the tip of your felt pens and give you a little more mileage with each color.

It is also very useful for reverse drawing, described in Chapter 6.

THE LIGHT BOX

The light box is a metal box supporting a sheet of frosted glass which is illuminated from underneath by fluorescent tubes. It's a very handy piece of equipment if you want to redraw a sketch onto a new piece of paper.

Tape a clean sheet over your original drawing, place them against the glass, and turn on the lights. You'll see the image clearly through the top sheet, enabling you to trace it in the same technique or to try a new one.

If you trace a drawing, you may have a tendency to stiffen up. To maintain the fresh spontaneity of your original, trace it in the same amount of time you spent on your first sketch: if you spent 45 minutes on your drawing, then spend 45 minutes tracing it. Stay loose and make some changes as you trace. This will give your traced version a freshness of its own.

A FINAL WORD ABOUT MARKERS

At present, the dyes used in felt markers are not permanent. When exposed to sunlight, the colors fade. The best advice I can pass along to you about preserving your drawings is to have them framed under glass and hung away from sunlight.

Sneakers. *Reverse drawing done with Marsh felt pen on 11" × 14" sketchbook paper. This pair of sneakers illustrates reverse-line drawing, which we'll be discussing in the chapter coming up, as well as in Chapter 6.*

Bicycles. *Pentel on 11" × 14" sketchbook paper. Four bikes in a row create some interesting shapes. The sketch began with the nearest handle-bar, and the other bicycles were added piece by piece. This was a difficult subject to stay with due to the multitude of overlapping parts.*

2

TYPES OF LINE

I love to do line drawings and I hope to infect you with some of my enthusiasm! A well-drawn sketch using line can be a thing of beauty.

I have selected eight types of line for this chapter, but I'm sure that as you start drawing on your own you'll discover many more.

Pick one you feel at ease with and rely on it for your basic drawing—no matter what the subject.

Let's examine the eight I have picked and see what they can do for you.

DIRECT LINE

A direct line is an even-weight line that is crisp, clean, and pure, with no frills. The best marker for direct-line drawing is a fine-line marker, such as a Pentel. A direct line is the most difficult to develop; a steady hand and an uncompromising eye are two requisites for success.

SKETCHY LINE

This is a good line technique to begin with. You can control short strokes better at first and it will build up your drawing confidence. A good style for almost any subject.

THICK AND THIN

If you are just beginning to draw you may find that you have an uneven hand pressure. This will result in your line appearing thick in some spots and thin in others. Eventually you'll learn to control your hand pressure, so you can place the thick or thin lines where you want them. A very serviceable technique.

BOLD LINE

A Marsh felt pen is ideal for bold line work. If your subject is of a robust nature, a bold line handling can really add impact to your visual story. Similar in look to Thick and Thin just described.

REVERSE LINE

The Marsh pen and Magic Marker pin stripe are of such moist ink quality that they will bleed through thin sketchbook paper to create a mirror image of your subject on the reverse side. The quality of this reverse line can be quite charming and you may like what you see better than your original sketch. More about this in Chapter 6, Reverse Drawing.

TEXTURED LINE

A textured line results when you draw on a rough surfaced paper. It's a sort of now you see it, now you don't line that is tricky to get hold of at first. Looks a little like a charcoal line.

NERVOUS LINE

David Stone Martin, noted illustrator, made this line quite popular some years ago. As you draw you stop after a short stroke and back up slightly and start again. Sounds tedious, but isn't. Nice for decorative drawings.

DECORATIVE, OR STYLIZED LINE

The secret for this line is to simplify. Any subject can be stylized. Just keep your line free and moving. Try to get as much out of as little as possible! Your finished drawing may have more design than realism, but that's the fun you can have with this line.

The same subject drawn with different kinds of line:

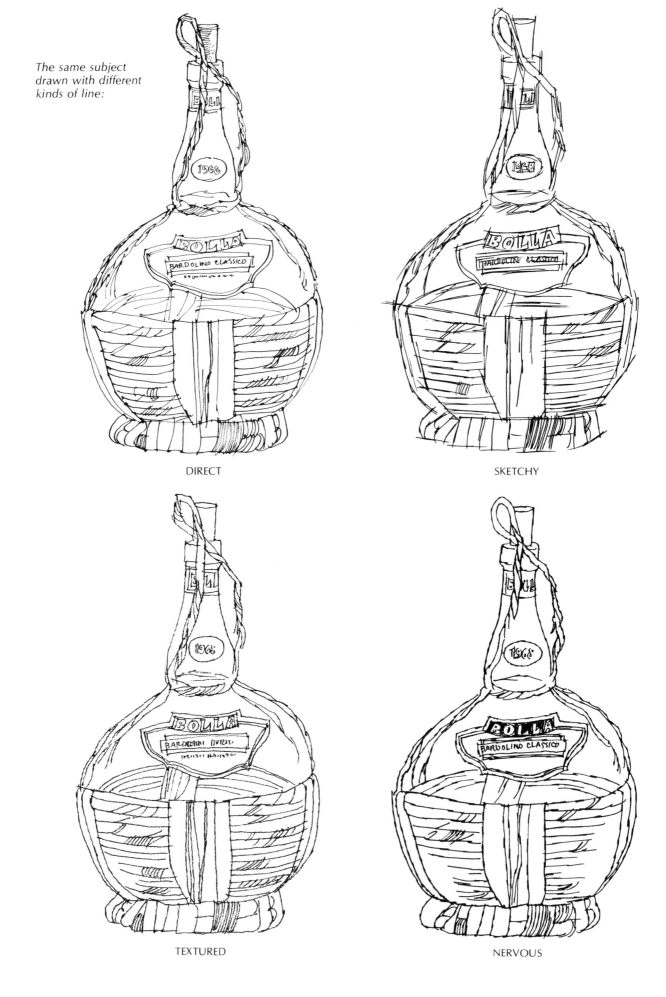

DIRECT

SKETCHY

TEXTURED

NERVOUS

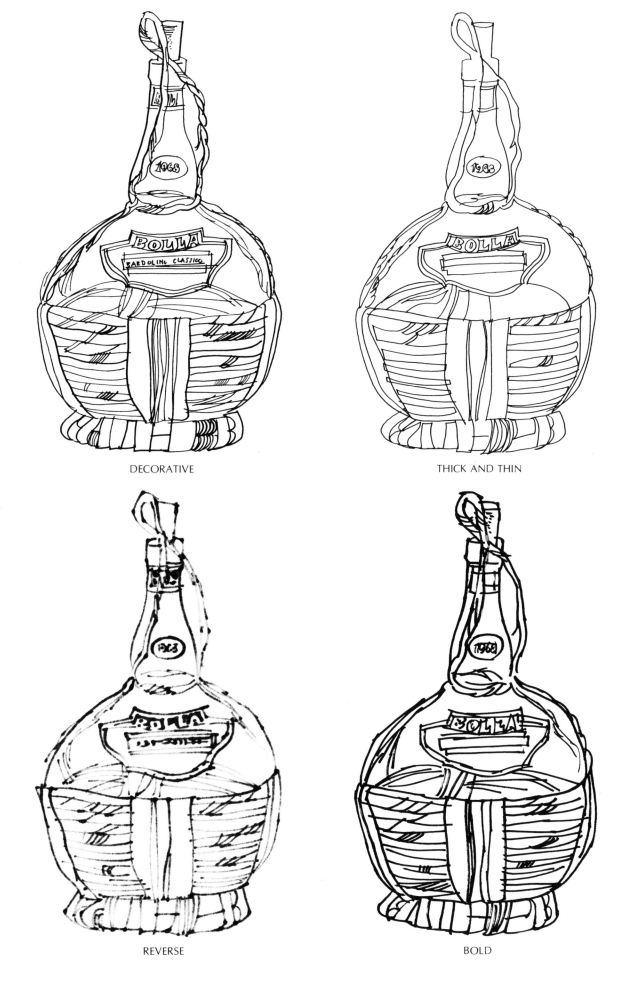

DECORATIVE

THICK AND THIN

REVERSE

BOLD

Sketchy Line. *Pentel on 11″ × 14″ sketchbook paper. I began this drawing of an outdoor art show with the figure at the left and progressed across the paper to the right.*

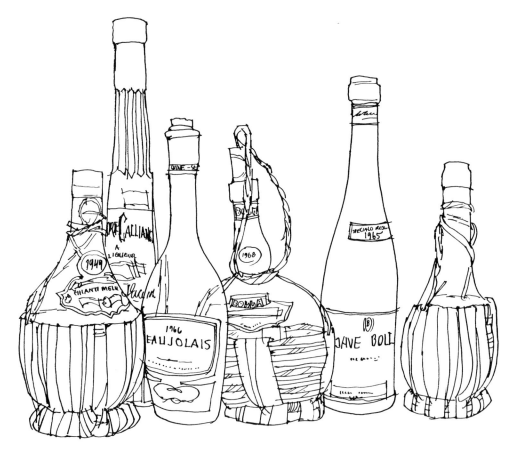

Direct Line. *Pentel on 11″ × 14″ sketchbook paper. The even-weight direct line gives all six wine bottles equal prominence.*

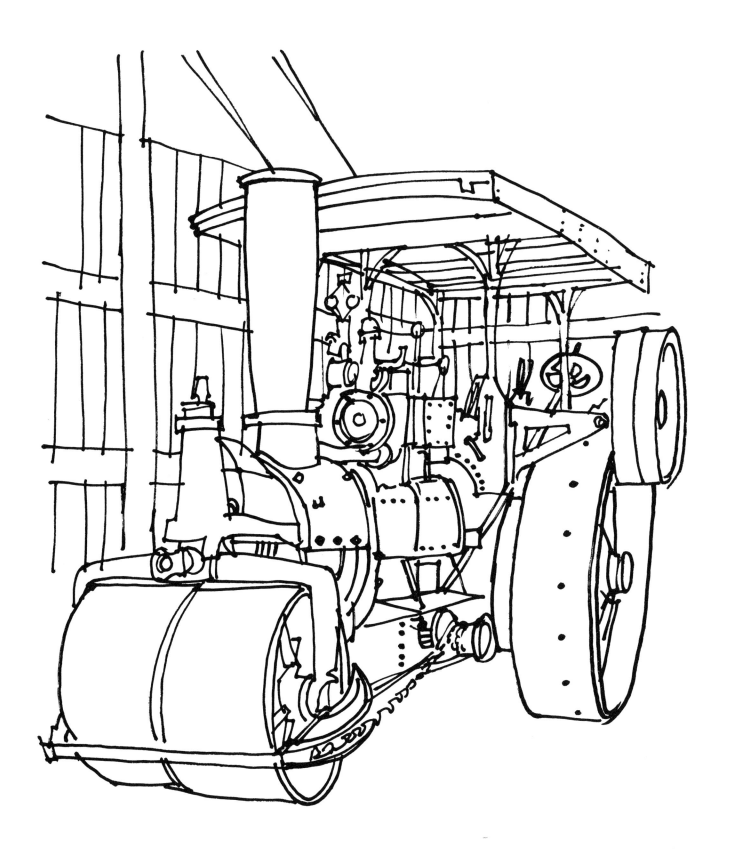

Bold Line. *Marsh felt pen on 14" × 17" sketchbook paper. I began drawing this steam tractor with the smokestack, which set a scale for the rest of the parts.*

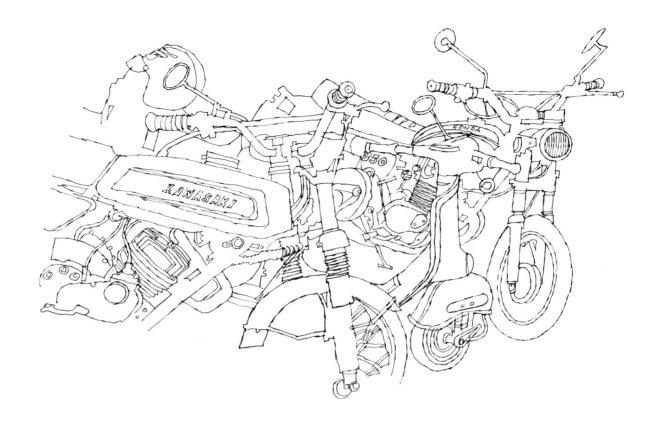

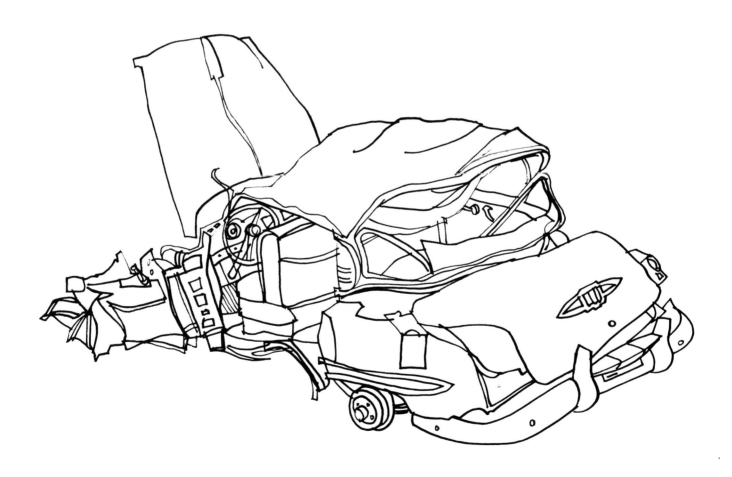

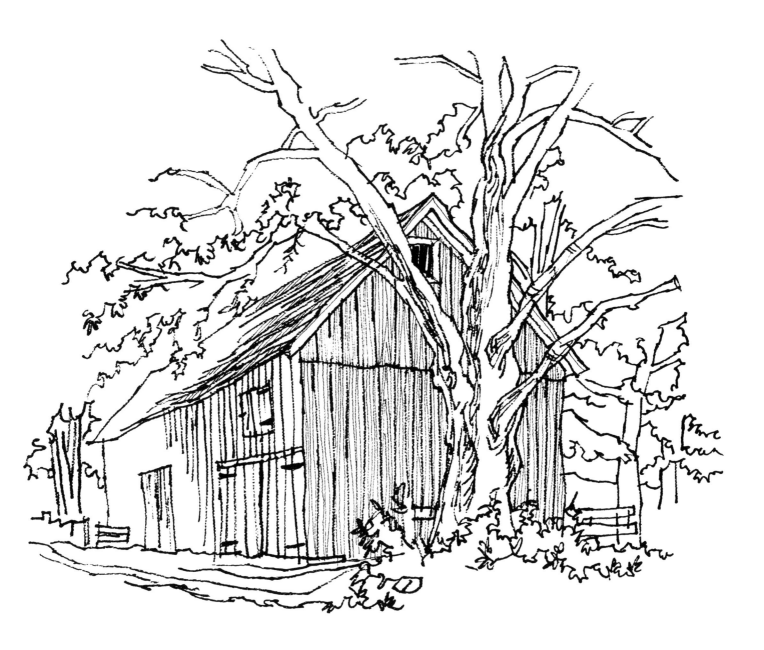

Nervous Line. *(Left Above) Pentel on 11″ × 14″ sketch-book paper. This sketch of three motorcycles began with the nearest pair of handlebars and the other parts were fitted in around them. The result is an eye-catching pattern of wheels, cylinders, seats, gastanks, and related parts.*

Thick and Thin. *(Left) Marsh felt pen on 14″ × 17″ sketchpad paper. This wrecked Chevy was drawn just as I found it while out doing some sketches of highway construction. The raised hood was drawn first, the rest of the car in relation to it.*

Textured Line. *(Above) Marsh felt pen on rough-surface drawing paper. The tooth of this paper gives the line in the old barn a nice ragged quality. You can control the look of your line by pressure: the harder you press down, the less ragged the effect; the lighter the pressure, the more broken up the line will appear.*

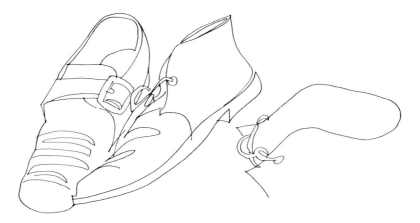

Step 1. This is going to be a decorative-line drawing of three pairs of shoes done with Pentel on 15″ × 20″ sketchpad paper. I begin with the shoes at the top of my composition because it seems like a good starting point. I indicate some of the shapes with a loose, flowing line.

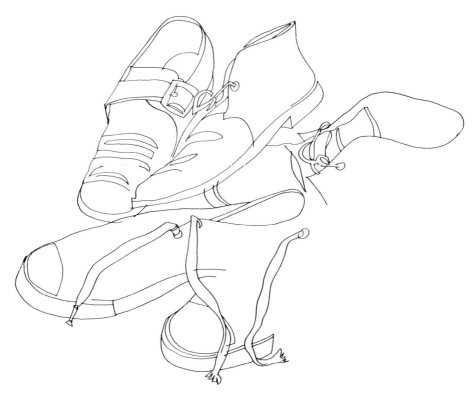

Step 2. In decorative-line drawing, you can interpret your subject with a careless abandon, yet stick to facts. Don't worry if your lines overlap in spots. This can add fluidity to your drawing.

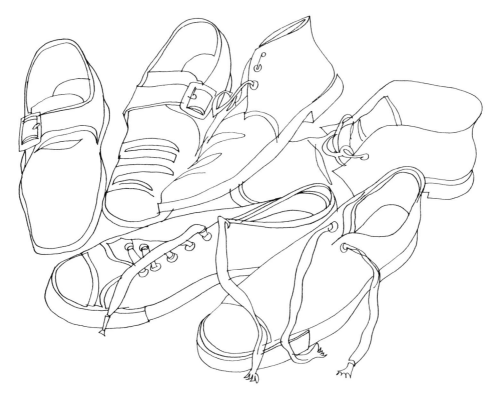

Step 3. All six shoes have been drawn at this point. Creases in the tops have to be simplified, as in the pair at the upper left. Notice the languid look of the shoelaces in the sneakers. Should you draw shoes, remember to make the laces part of your composition.

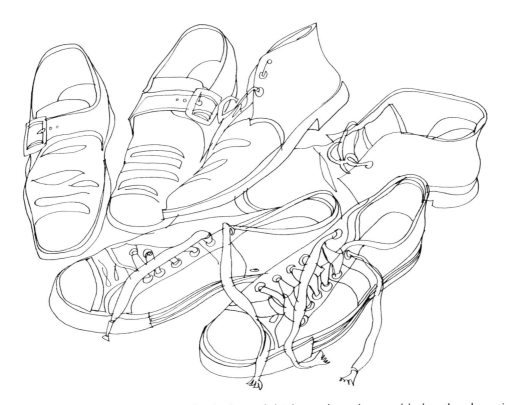

Step 4: Shoes. Additional creases, laces, and a feeling of thickness have been added to the shoes in this, the final step. You can go further with a subject like this by trying it in nervous line, thick and thin, and reverse line.

Decorative. *Pentel on 11" × 14" Strathmore medium-surface paper. This type of nervous line is fine for a subject you want to treat in a decorative, nonrealistic manner. It's a challenge to use only one tone to achieve your shading.*

3
LINE AS TONE

The previous chapter explored the various types of line you can create with markers. Now let's see what you can do to create tones by using only lines.

You've seen lots of drawings done in this style. In fact, I think it's safe to say that our visual education began with our first attempts to read the comics with their wonderful black and white drawings that magically seemed to simplify everything the artist's pen touched! (I wish I had a nickel for every hour I spent copying comics in my youth!)

Okay, let's see how these tones are created and how we can use them in our drawings.

DIRECTION OF LINE IS IMPORTANT

The simplest way to create a tone is with a series of closely spaced lines. These lines can be drawn vertically, horizontally, curved, or at an angle. Think about what you want your tone to accomplish before you draw it in: vertical lines can impart an "up and downness," such as in a wall or the side of a building. Horizontal lines can give you the feeling of flatness, such as on the ground or on a tabletop.

Shading at an angle works well when you want to indicate a tone and you're in a hurry or you have a large area to cover.

Curved lines are best if your subject is curved. Follow the contours of the object; this will help impart a three-dimensional look to your sketch.

ACHIEVING A DARKER TONE

A darker tone can be created in two ways. (1) Bear down with your marker to make a thicker, blacker line. This is fine for bold effects. (2) Draw in your tone, then draw another set of lines at a slightly dif-

ferent angle over it. Should you want something darker still, add a third set at another angle. Try not to get heavy-handed with your tones. It's better to err on the light side than the heavy side. Take a good look at some of Van Gogh's line drawings to see how a master's hand creates texture and tone with lines.

PRACTICE DRAWING TONES

Spend an hour or two drawing tones. See what you get with closely spaced lines and widely spaced lines. Add another set over these to see just how much darker they appear. Draw lines slanting from the left; draw some slanting from the right. Let them overlap to create a crosshatch. Draw some curved lines to represent a tone on a round surface. The direction of line is very important, isn't it?

If you have a bag full of tones up your sleeve before you start using them you're going to be just that much better off when you apply them to actual situations.

VISUAL SHORTHAND

I can't stress enough that you should keep your tones simple, no matter how complex the shading looks on your subject. Try to create a center of interest with your tones by making them more interesting in that area. Your tone doesn't have to be darker to be eye-catching. A simple trick like changing the direction of your lines can do wonders to lead your eye where you want it to go. There's a little bit of magic in drawing and when you start to think visually, it begins to come automatically. When this happens, the tremendous feeling you get from drawing can't be measured.

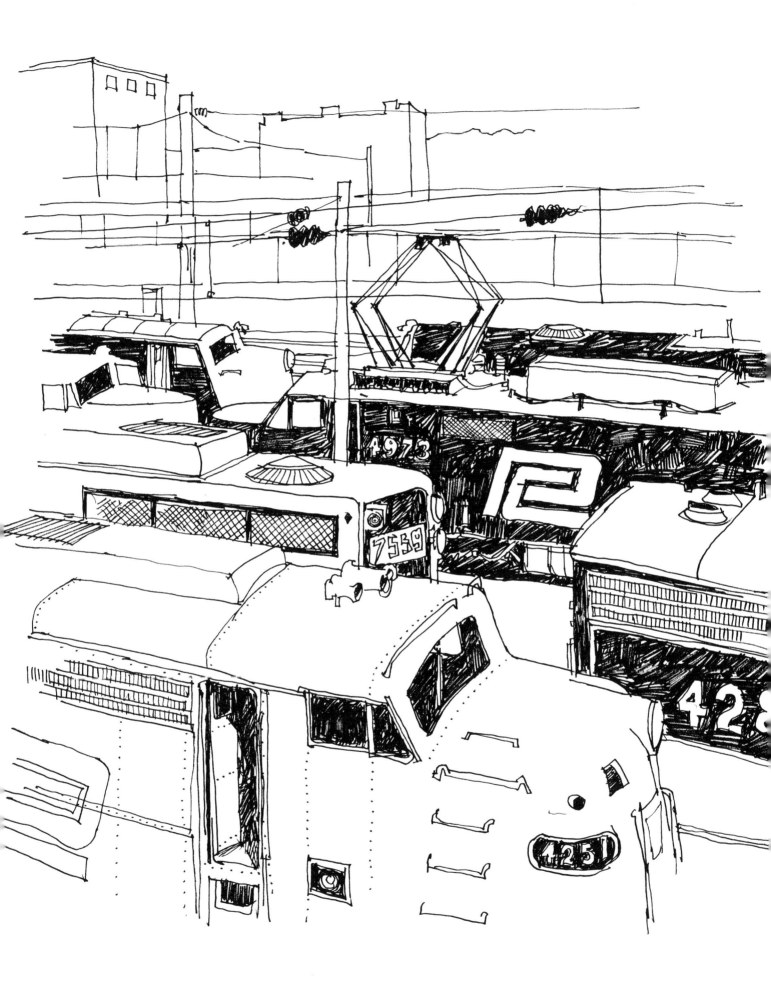

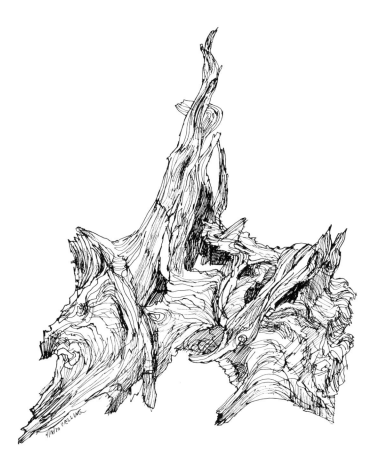

Wood Texture. *Pentel on 11" × 14" sketchbook paper. Driftwood is interesting to draw. The lines should be kept light; follow the contours of the wood and draw in the pattern of the wood grain.*

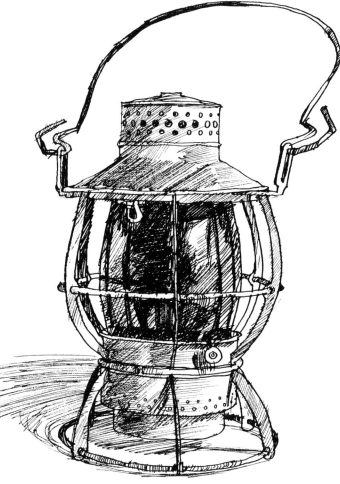

Mixed Technique. *Pentel on 11" × 14" sketchbook paper. Anything goes in drawing so long as you are pleased with your results. This old lantern demonstrates line used for shading on a slant, for direction, and to show boldness. They all work together to portray the subject.*

Bold Tones. *(Opposite Page) Pentel on 11" × 14" sketchbook paper. One heavy tone can do wonders for a black and white drawing. A nice effect is achieved by pressing down pretty hard and changing the direction of your lines. This avoids a monotonous look to your tone.*

Woodcut. *Marsh felt pen on 11" × 14" sketchbook paper. Old barns are a natural for this technique. Keep your handling bold, and limit yourself to three or four tones. Heavy pressure will give you bold lines; a lighter touch is required for thin lines.*

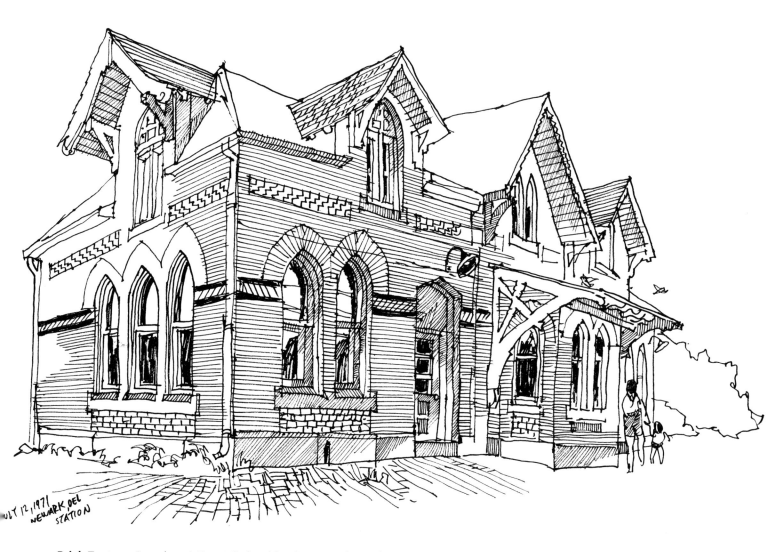

Brick Texture. *Pentel on 11" × 14" sketchbook paper. If you draw your bricks on the shady side of your building, you'll create the texture of the surface along with a feeling of shading. For a darker tone, add some lines at a slant over your bricks.*

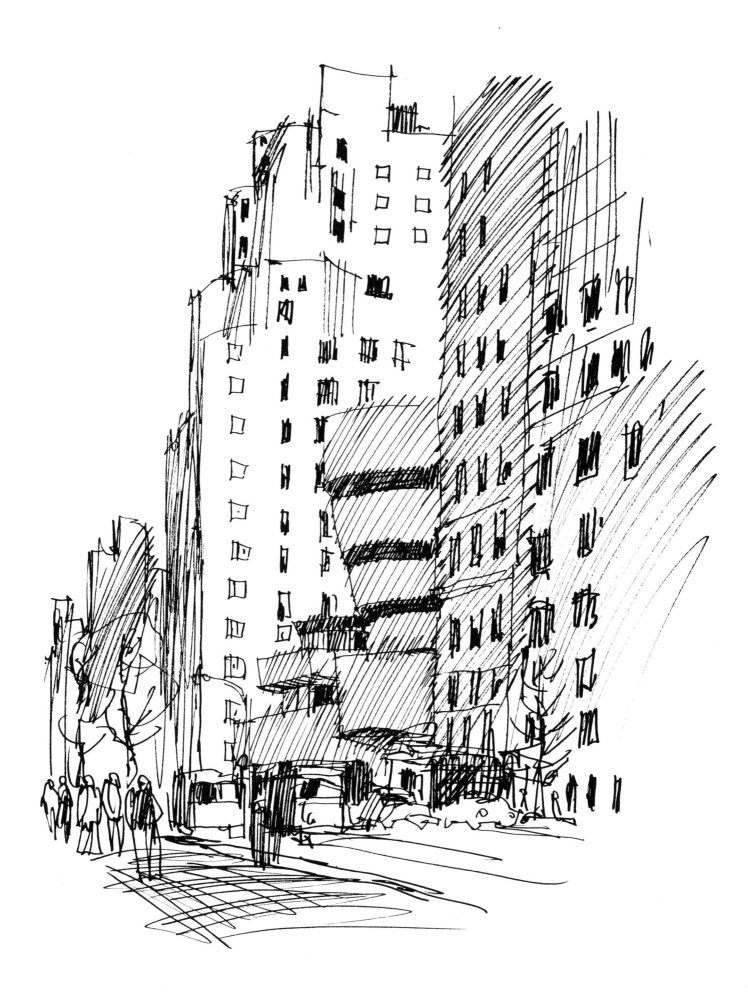

Quick Sketch. (Left) Pentel on 11″ × 14″ sketchbook paper. This sketch of the Guggenheim Museum was completed in 15 minutes. When working this fast your shading has to be automatic. A simple slant to your lines is adequate to separate the elements.

Automobiles. (Above) Pentel on 15″ × 20″ sketchpad paper. Drawn from a fourth-floor window. The various cars were drawn as they waited for the light to change. Bold line shading was added to the street to make the car forms more prominent and hold all the shapes together.

Direction. *Pentel on 14" × 17" sketchpad paper. A slightly used Pentel gave me the weight I wanted for this sketch of two derelict boats. The direction of lines adds form to the planks in the hull. Make sure your lines help define your subject and are not confused with slanted shading lines.*

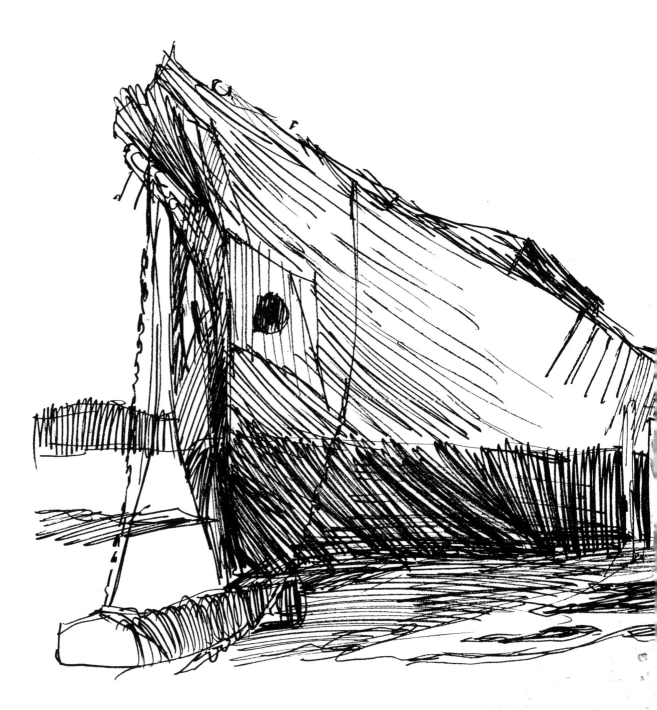

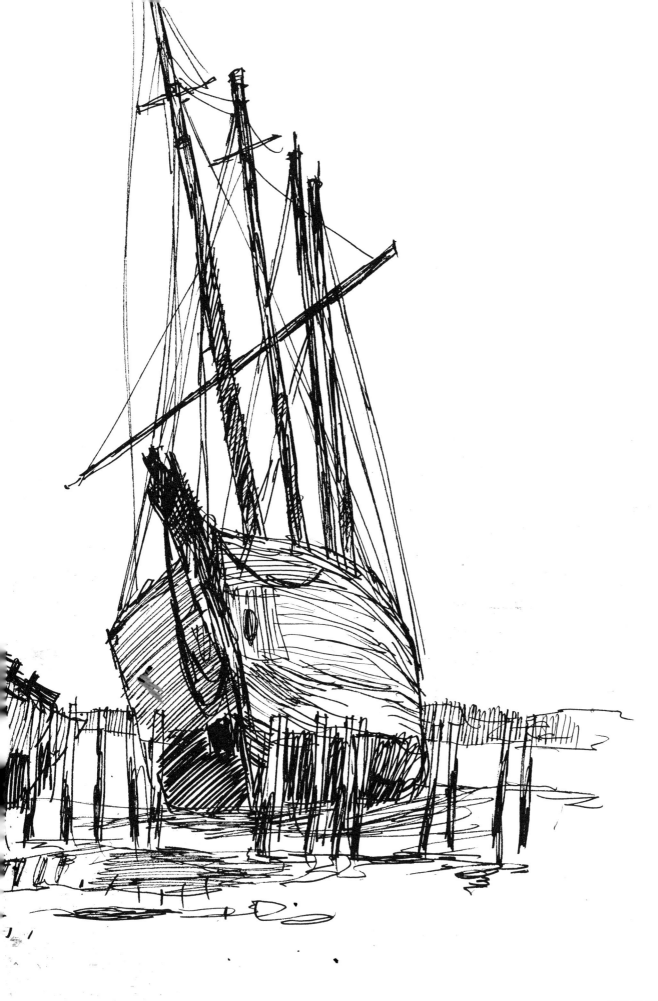

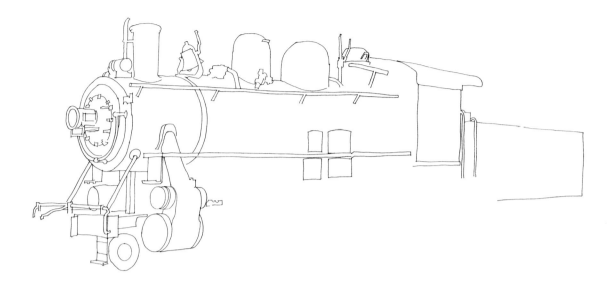

Step 1. Drawing directly in Pentel on 18″ × 24″ sketchpad paper, I begin with the top and front of the locomotive. The spaces between the domes on top of the boiler establish correct positioning. I'm using a very light touch with my Pentel to maintain an even-weight line.

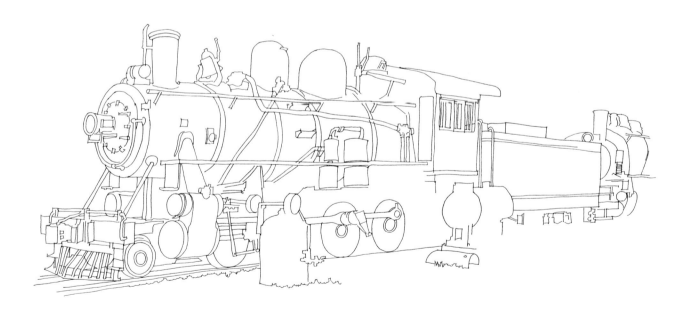

Step 2. More details have been added, including another engine in the background. My ovals for the wheels aren't perfect, but they aren't bad either. Drawing in the track will help in the correct positioning of the wheels. A locomotive is full of interesting curved surfaces and old-timers always seem to be numbered 97. I wonder why?

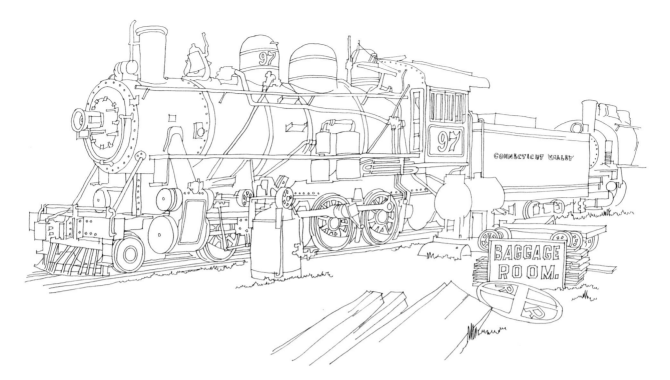

Step 3. Here's the completed contour drawing which due to its outline technique almost resembles a mechanical drawing. This sketch is fine as it is but let's go on to the next step and add some line shading.

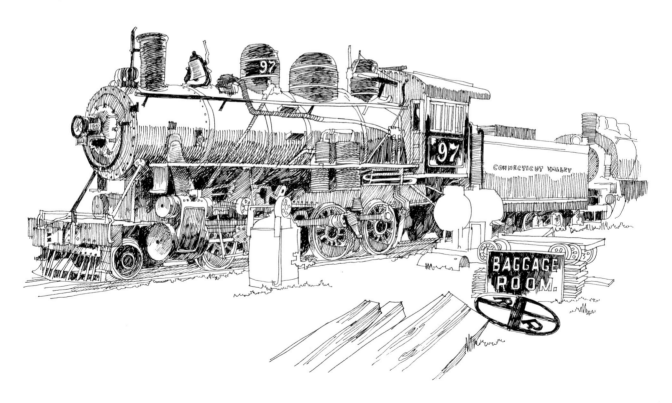

Step 4: Old 97. Following the basic contours of the parts, I have used my lines as tone. The boiler, stack, and domes look round, while the side of the coal car looks flat because of the direction of the lines. Several punchy spots of black have been added for visual interest. If you should ever visit Essex, Connecticut, you can draw this engine yourself.

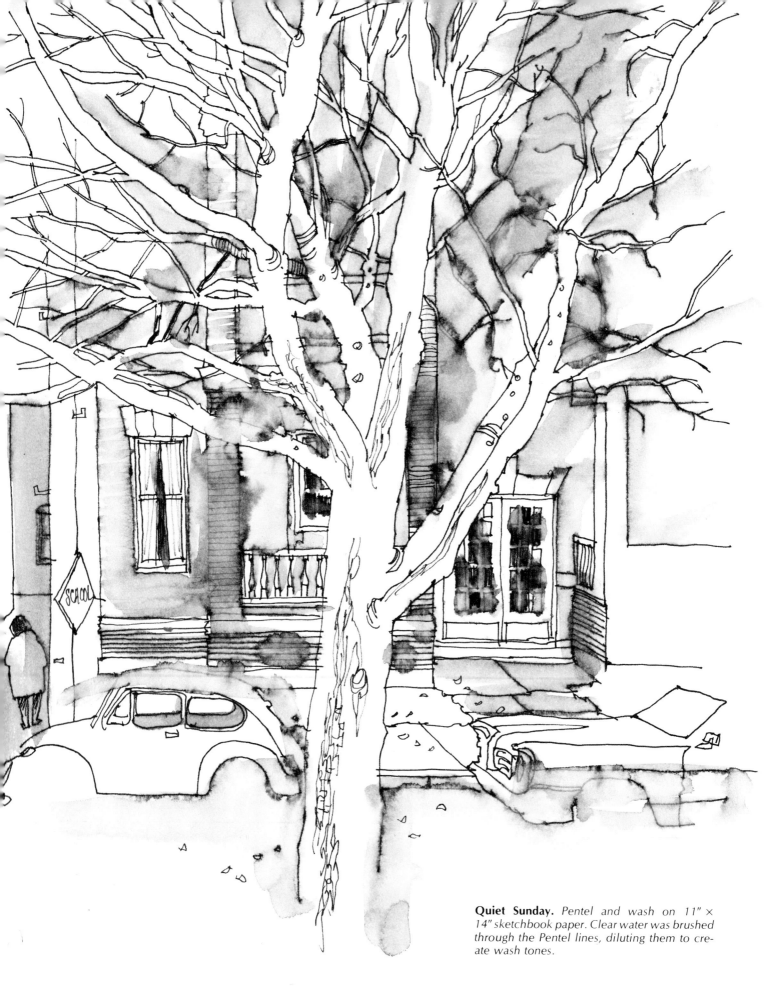

Quiet Sunday. *Pentel and wash on 11" × 14" sketchbook paper. Clear water was brushed through the Pentel lines, diluting them to create wash tones.*

4
LINE AND TONE COMBINED

Chapters 2 and 3 introduced you to the almost limitless possibilities available with different types of lines and using line as tone. The drawings you complete using line only are quite satisfactory in themselves, but suppose you want to add gray tones for emphasis. How do you do it? Let's find out.

REALISM IS INCREASED

When you start to add tones of any sort to your work you'll find your drawings taking on a more realistic look. This is because our physical world is made up of patterns of light and dark shapes, and when you interpret these shapes with tones it's easier for the viewer to understand what you were trying to do.

SIMPLICITY IS IMPORTANT

When you start using tones, always try to keep them simple. This may be difficult at first because the markers are so much fun to use. But remember: it's very easy to overwork a sketch!

Begin with one tone and use it on a tree trunk, in a person's clothing, or for the shadow side of a building. Notice how the tone ties your line work together and adds greater solidity to your sketch.

PICK THE RIGHT TONE

Warm gray tones are excellent for tone work, and since they're transparent they won't hide your line drawing. You can accomplish an awful lot with three tones—say Nos. 3, 5, and 7. Value 7 is pretty dark and might hide your lines so use it for accents, sparingly.

Values 3, 5, and 7 are spaced nicely to give a visible difference. If you were to use tones that are closer together—3, 4, and 5 for example—your sketch might be a little on the dull side. When using marker grays it's important to get as much contrast as possible. Values 2 through 7 are the most active

tones. Values 8 and 9, being very dark, should be used sparingly. Both 8 and 9 can be used to indicate a nighttime sky if you do a night study in grays.

PENTEL WASH

Another method for achieving tone is with Pentel wash or any other water-soluble brand of markers. Just brush clear water through a section of your sketch, and the ink will dissolve into a wash tone. With Pentel, only the black has this capability; it will dissolve into a bluish tone. The more ink you've used in your sketch, the darker the tone will be when saturated with water. Keep a paper towel handy and blot when you see the tone is going to be too dark.

Try to get your wash effect right the first time: rewetting tends to create a muddy area. Practice on scrap paper first.

PENTEL WASH AND MARKERS COMBINED

You might like to try a mixed technique, using water-soluble markers and regular gray markers in the same sketch. A wash effect can be created even if you've first added marker tones over your line drawing. Even though it's not water-soluble, the marker ink doesn't prevent water from dissolving the Pentel ink. A happy state of affairs!

DRYBRUSH

Drybrush gives you a great deal of control, enabling you to create very subtle tones and interesting effects. The drybrush technique is actually done with a brush that is very slightly moist rather than really dry. Wet the brush, dry the bristles on a paper towel, and lightly brush it through the area you're working on. By using just the tip of the brush, you'll be able to get a light line. If you scrub the brush across your drawing, you'll create a larger, ragged tone.

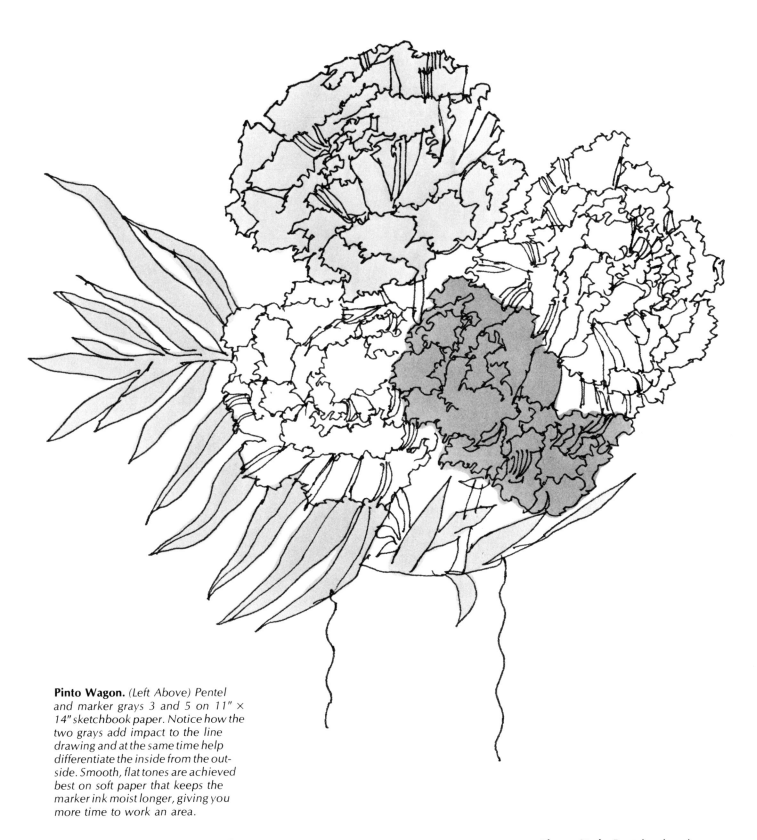

Pinto Wagon. *(Left Above) Pentel and marker grays 3 and 5 on 11" × 14" sketchbook paper. Notice how the two grays add impact to the line drawing and at the same time help differentiate the inside from the outside. Smooth, flat tones are achieved best on soft paper that keeps the marker ink moist longer, giving you more time to work an area.*

Calder's Masterpiece. *(Left) Pentel and marker gray 3 on 15" × 20" sketchpad paper. One tone of gray can be as effective as many if you put it in the right spot. Because of the tone, the shapes in this Calder sculpture jump right out at you from the background.*

Flower Study. *Pentel and marker grays 1, 2, and 4 on 11" × 14" sketchbook paper. Put your tones where they will do the most good. The two tones on the flowers help break up the pattern and add solidity to the shapes.*

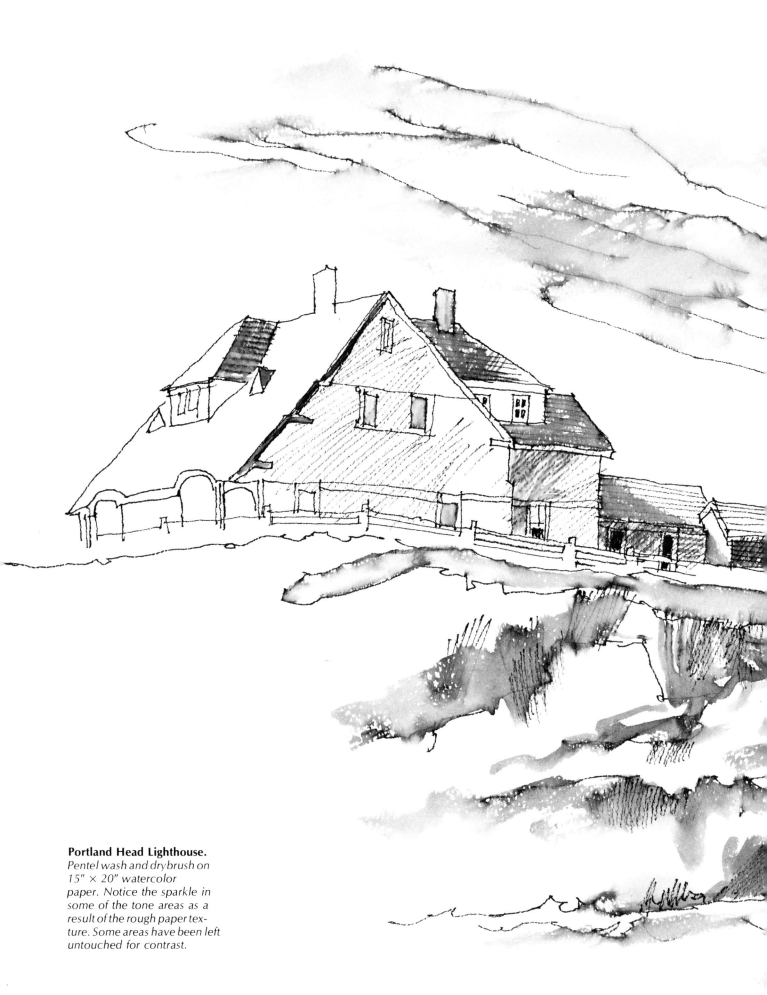

Portland Head Lighthouse.
Pentel wash and drybrush on 15" × 20" watercolor paper. Notice the sparkle in some of the tone areas as a result of the rough paper texture. Some areas have been left untouched for contrast.

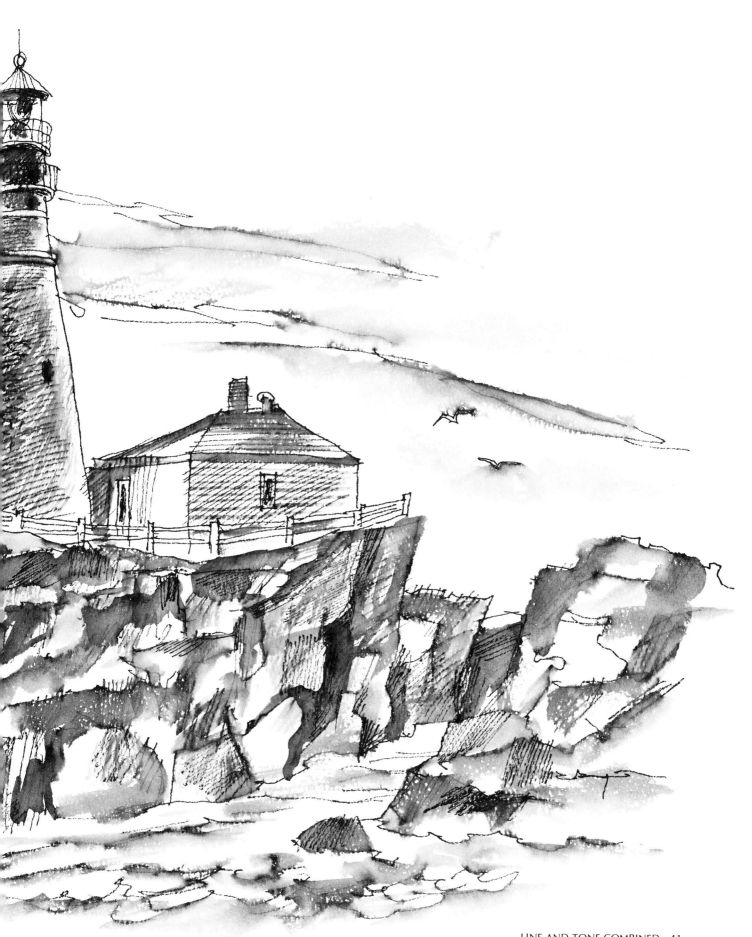

Step 1. Pentel and markers on 15″ × 20″ sketchpad paper. I begin to draw some of the signs in my composition with a Pentel. In order to get the effect I'm after, I change my position several times to tighten up the spaces between elements.

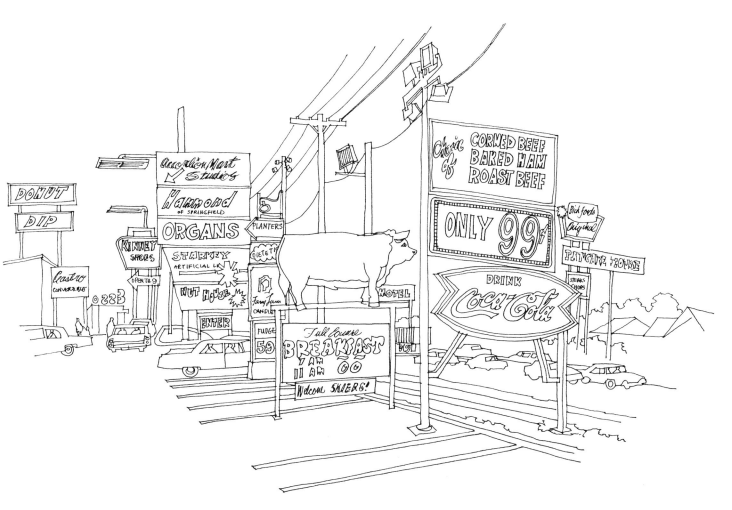

Step 2. Here's the complete direct-line sketch; it came out pretty much as I had hoped. If you try a subject like this, pay attention to the various letter styles for added realism. Cars in the background kept zipping along so I had to draw their shapes and compose them as best I could.

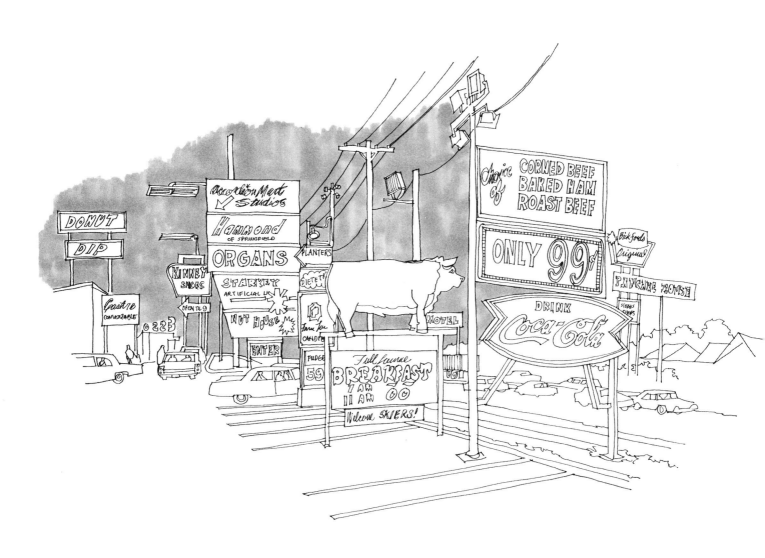

Step 3. The sky has been partially filled in with gray No. 3. Notice how it makes the signs stand out. Gray in combination with line is a very workable technique.

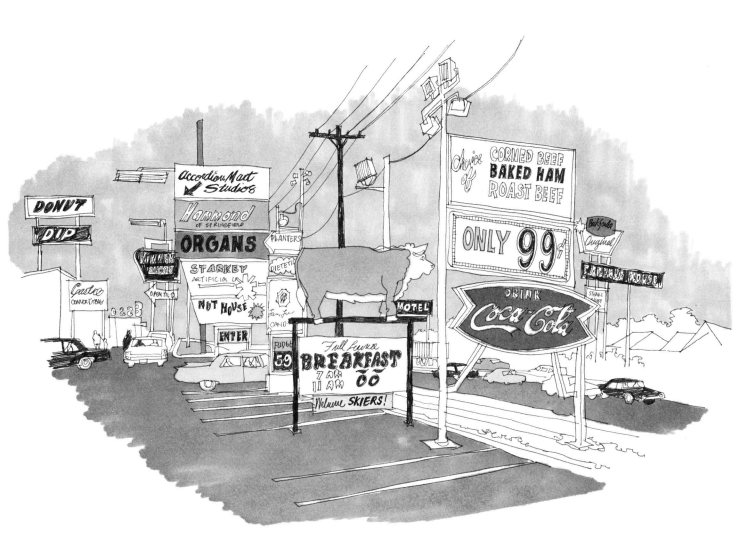

Step 4: Roadside Signs. Gray No. 5 has been used for the road and parking lot. No. 6 was used on the Coca-Cola sign to give it a spot of prominence. My grays have bled over some of the lines, but I don't find that objectionable. Sky and ground tones have been vignetted for visual interest.

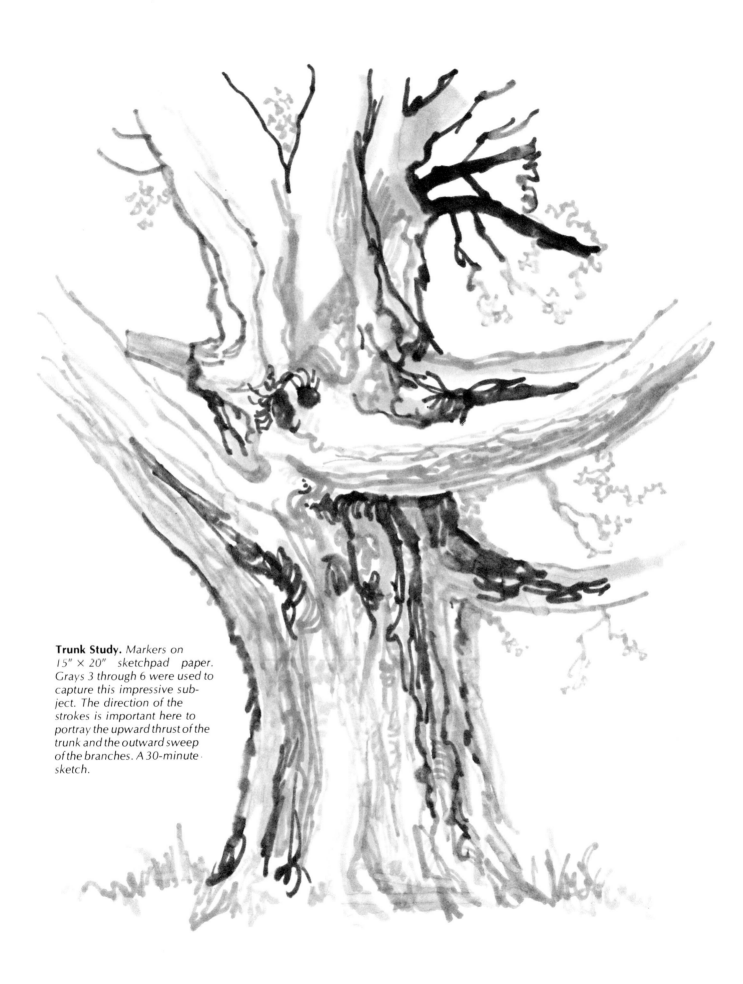

Trunk Study. *Markers on 15" × 20" sketchpad paper. Grays 3 through 6 were used to capture this impressive subject. The direction of the strokes is important here to portray the upward thrust of the trunk and the outward sweep of the branches. A 30-minute sketch.*

5
DRAWING WITH TONE

Last but not least we arrive at drawing with pure tone. With this technique you have no supporting line structure to aid you in completing your sketch.

Other than working in color (which I'll cover in Chapter 9), drawing in shades of gray produces the closest semblance of reality.

THE GRAY SCALE

Felt markers come in a range of gray tones from very light (No. 1) to very dark (No. 9). There is also a black available, but it's so dark that if you use it in a tone sketch it stands out too much. Stick with grays 1 through 9 and I think you'll be happier with your results.

Markers come in warm and cool grays. For general drawing work, the warm grays are easier to work with and seem more natural to the eye.

MAKE A GRAY COLOR CHART

It might help you in the beginning, when you're translating color into an appropriate value of gray, to make a color chart. This is simply a strip of paper with the nine values drawn on it side by side.

To judge a color, hold the strip in front of your eyes and move it back and forth until you see a value of gray that comes close to the value of the color you're matching. After a while you won't have to use the chart at all. Your eyes will tell you which gray to use.

DRAW YOUR SUBJECT IN PENCIL FIRST

When you've found a subject that intrigues you, draw in the basic shapes lightly with a soft No. 2 pencil. Keep your lines light so you can erase them with a kneaded eraser if you have to make corrections.

As you get more skillful in drawing, try to make your pencil lay-in as brief as possible so you rely on your eyes and markers to do the work.

Eventually (and this takes courage!) you won't need any pencil work at all but will go right into your sketch with the markers. It's an exciting feeling to have a fresh sheet of paper in your lap, a set of grays at your side and an eye-filling subject in front of you!

WORK FROM LIGHT TO DARK

Once you've put down a tone it's there for good. You can't remove it and if you find that it's too dark you'll have to adjust the other values in your drawing or start over. It's best to start with the light tones first, because any tone can be darkened, but not lightened. To keep your drawing fresh looking, try to get the value of your tone right the first time.

DIRECTION OF STROKES

The direction of your marker strokes can help your sketch quite a lot: vertical for sky, horizontal for grass and ground, and curved if your subject has curved surfaces (such as the hull of a boat). You have a lot of latitude here. You don't have to take this as an absolute rule, but if you should run into a subject that confuses you, you can't go wrong if you follow the contours of the object.

TONE TECHNIQUES

If you draw rapidly with a marker your strokes can take on a pencil-like quality; that is, your sketch has the look of a pencil drawing.

By filling in tone areas slowly, you can create some lovely, smooth tones that almost look as though they were printed by a machine.

If you hold a marker so you draw with just the tip you can draw thin gray lines; this leads to all sorts of possibilities. For example, the areas between lines can be filled in with contrasting values for a nice poster treatment.

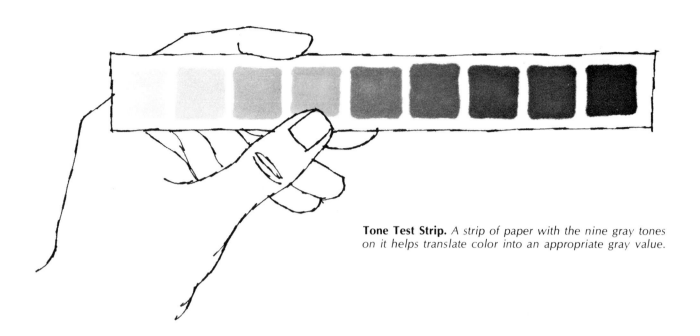

Tone Test Strip. *A strip of paper with the nine gray tones on it helps translate color into an appropriate gray value.*

Wrecked Car. *Marker grays 2, 4, 6, and 8 on 11" × 14" sketchbook paper. The shape of the car has been drawn with a No. 6 gray and the other areas carefully filled in to complete the design. Thin lines in gray can be handled nicely if you draw them quickly; if you hesitate, your line will turn into a blob.*

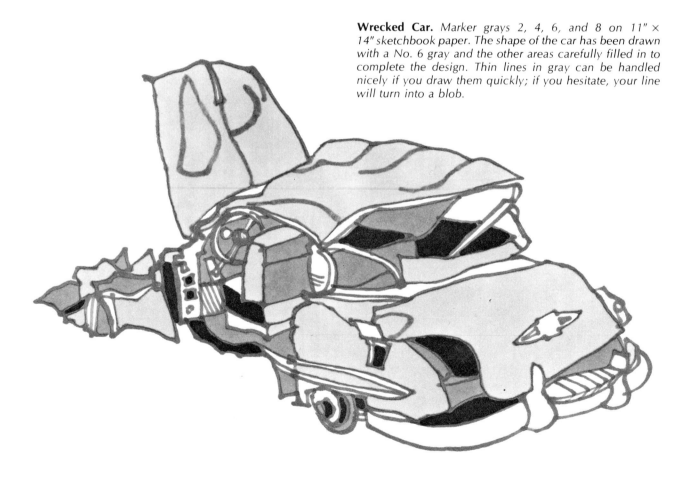

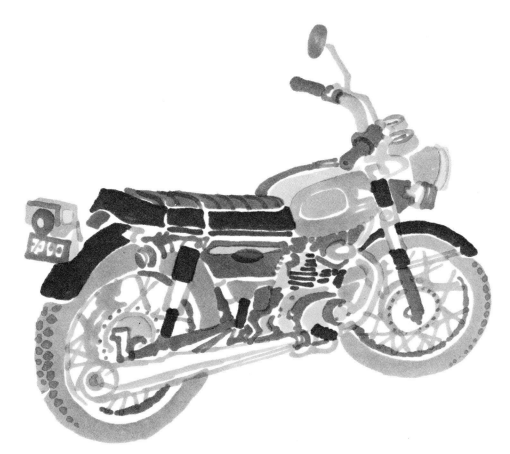

Motorcycle. Marker grays 2 through 7 on 11" × 14" sketchbook paper. I drew the shapes of the machine with the tip of the markers to retain as much clarity as possible. Liberties have been taken with the mechanical parts to create a better overall design.

Camden, Maine. (Below) Marker grays 2 through 7 on 11" × 14" sketchbook paper. This is based on a line drawing in Chapter 10, Boats and Harbors. The gray tones were carefully placed to add to the composition. A lot of white paper has been left untouched to highlight the effect of sunlight on the scene.

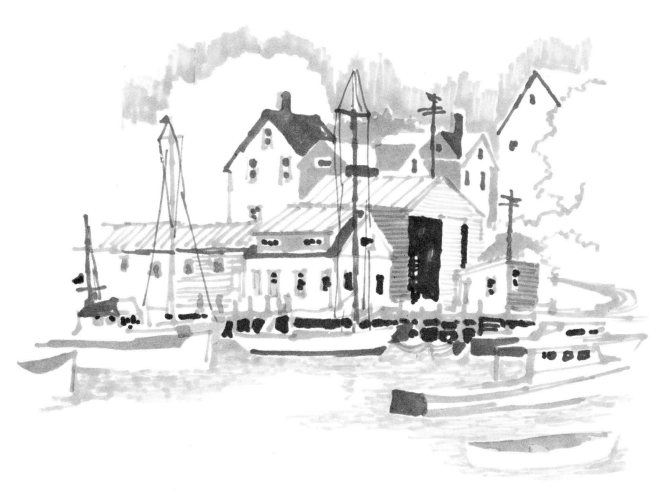

Step 1. This is a view of eight brownstones on 78th Street, Manhattan, done with marker grays 2 through 9 on soft 15″ × 20″ sketchpad paper. Using grays 4 and 5, I have indicated the shapes and windows of three of the buildings. The gray tones approximate the actual colors of the structures.

Step 2. Parts of all eight fronts have been drawn at this stage. Gray No. 3 has been used on the building at the right, the two in the background and the façade on the left. No details have been started yet, as it is a good idea to save them for last.

Step 3. Notice the nice range of values the gray markers give you. My tones spread slightly on the soft paper before they dry, adding a little diffusion to the edges of my values. Drawing directly, without any pencil lines to guide you, is a splendid way to develop your hand and eye.

Step 4: Brownstones. Window details, cornice trim, and steps finish the drawing. The stone texture on some of the fronts has been simplified to retain a fresh look. You can see this same view in color on page 90.

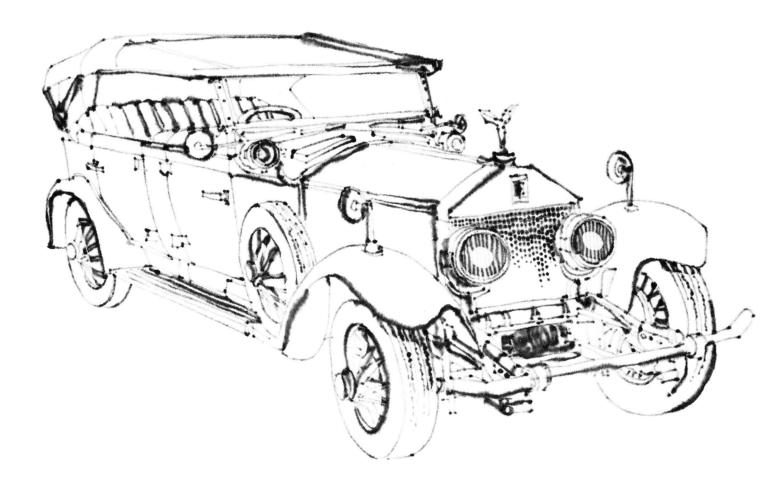

Rolls-Royce. *Reverse drawing on 14" × 17" sketchpad paper. The original sketch was a line drawing; this is the traced version done with a fine-line Magic Marker. Some of the lines are very faint, while others have been strengthened with Flo-Master cleanser. Notice the three-dimensional look achieved with only one color.*

6
DRAWING IN REVERSE

Some lovely effects are possible when markers bleed through a sheet of paper to form an image on the reverse side. A few years ago, I discovered that moist markers would bleed through my soft sketchpad paper to create another view of my scene only with all the elements backwards, or in reverse. For some strange reason my eyes reacted favorably to the lovely, soft, atmospheric effects I was creating on the other side of my paper and I made up my mind to turn this reverse effect into an actual marker technique.

THE BACKWARDS LOOK

As stated above, everything in a reverse drawing is just that: in reverse. How important is it to have a correct right-left relationship in your work? Well, if you draw the right side of a street, showing a group of buildings with signs on them, when you turn your sketch over your reverse view will show the street on the left side. And of course all the signs will read backwards! If you "fudge" the lettering (make the letterforms so indistinct that they can't be read anyway) you can wind up with a finished drawing right on the spot. However, the relationship of the buildings to the street will still be incorrect—even though most people wouldn't pick that up.

There is a way to create a correct right-left relationship in a reverse drawing which entails drawing your subject twice. I'll explain this process a little later on.

SYMMETRICAL SUBJECTS

What subjects can you draw that will look okay when you turn your sketch over? Well, almost anything that's symmetrical. For example, a still life composed of flowers, bottles, and some fruit would work out fine. Just bear in mind that your composition will appear backwards when you turn your paper over. Boats are a splendid subject (if you work in color, remember to reverse the position of the red and green running lights to keep everything correct on the reverse side!). Cars are also fun to draw. Here, remember to put the steering wheel, if it shows, on the other side of the windshield. If you try a portrait, your subject's hair will be parted on the wrong side when you turn your sketch over. There are a lot of symmetrical subjects around that you can draw on the spot without resorting to the two-step method described next.

TWO-STEP REVERSE DRAWING

In two-step reverse drawing, you first make a detailed line drawing of your subject. I like to stick to a contour technique, but use anything you feel at home with. If you put in some shading, keep it simple. Next, trace your drawing backwards onto a new sheet of paper. I have a light box (see Materials) to assist me in this, but you can use a window just as well. Tape your drawing, facing away from you, to the glass. You will see the image through the paper backwards, or reversed. Now tape a new sheet of paper over your drawing. A bit of masking tape in each corner works fine. This new sheet is the one you'll be tracing on to create your reverse sketch.

You have a choice here of two working methods. (1) Trace your sketch in pencil, putting in all the details you see, then remove it from the window onto a horizontal surface and apply your markers. (2) Skip

the pencil work and jump right in, applying the markers while your drawing is still taped to the window. If you decide to draw directly with the markers, it's advisable to slip a sheet of clear acetate between the two sheets to protect your original sketch from becoming spotted as the markers bleed through the top sheet. (Most art stores carry acetate in 19" × 25" sheets.) Okay, now we're ready to use the markers.

USING THE MARKERS

Here's where the real fun begins, coloring in your work. Be sure your markers are fresh and moist; you'll have to saturate the paper thoroughly to get an image on the reverse side, as the values always appear slightly lighter on the other side. Experiment a bit on the same kind of paper you'll be using to see this effect.

When coloring in an area, draw slightly to one side of the image as you see it to allow for the tendency of the markers to spread slightly before they dry. With a little practice, you'll be able to set your colors to wind up just where you want. This spreading is very noticeable, on some of the handmade Japanese papers I use, and quite frequently the color will go past the edge where I want it to stop. When this happens I have to adjust my drawing if I can—or I have to start over.

If you work with your drawing taped to a window, you'll find that gravity effects the flow of ink in the marker. Be sure to hold the marker slanted down toward the area you're working on so the ink inside can reach the felt tip. This is not a problem when doing your drawing on a horizontal surface.

YOUR FIRST DRAWING

Try something simple, perhaps a tree without foliage. With a No. 2 or 3 gray, draw in the sky and run the tone right up to the branches, but except for the small branches don't cover them. The reason that you shouldn't cover the branches is that it's difficult to draw a darker tone over a lighter one once the paper becomes saturated with color. By drawing around the large branches, you leave blank paper for the darker tone to penetrate. I draw in this fashion for all my reverse drawings, no matter what the subject. Always leave blank paper showing wherever a different tone is going to go. You might think your sketch is going to wind up looking like a patchwork quilt with all those isolated spots of color, but it won't, believe me!

Remember, you can always darken a tone by going over it with a slightly darker value. But try to get it

right the first time, as you'll have to use a lot of color to penetrate the already saturated area. You can't lighten a color; once it has penetrated the paper it's there for good. You'll notice that in the reproductions of my reverse drawings in this chapter I leave a lot of white paper showing. I like this. It adds sparkle to the sketch and gets the viewer's eye involved in what's going on. There are no rules in drawing, as you know, so if you want to flood in a lot of blue for a sky go ahead. Let yourself go with this technique and you'll have more fun!

INTENSIFYING WEAK COLORS

As you work on your sketch keep checking your progress by turning your drawing over to see how the colors are bleeding through to create the reverse image. Keep in mind that your working surface is the top side of your paper and the finished sketch is what appears on the other side. You may find some areas where the color hasn't penetrated the paper enough to give the strength of tone you were after. Don't despair! There are two ways to strengthen light tones. The first way is to go over the area again with the same color, only drawing a little slower so more color gets through the paper. The second way is a little more involved, but you'll end up with a drawing tool you'll use again and again for reverse drawings.

Take a used-up No. 1 or 2 gray and remove the top. You'll see a block of felt inside. Squirt Flo-Master cleanser onto this block. Replace the top and test the felt tip on a scrap of paper. Some gray will show first but after a few seconds just clear liquid will appear. This little gadget is going to be our intensifier. Use it just like a marker. Draw over areas and lines you want darkened, only work more quickly than you ordinarily would. A little of this stuff goes a long way. One word of caution, however: while it does a good job of strengthening a color, our intensifier also softens edges as it spreads. Practice with it first so you can control it without fear of ruining a finished sketch.

A REVERSE OPTICAL ILLUSION

I'll end this chapter with an intriguing discovery I made while making a reverse drawing of Times Square. My line sketch included a sign with the letters AUTOMAT reading vertically. When I turned my drawing over to draw it backwards this sign still read AUTOMAT! Because of the vertical symmetry of the letterforms, and because the word was vertical rather than horizontal, the sign read the same way when it was reversed as it did right side up!

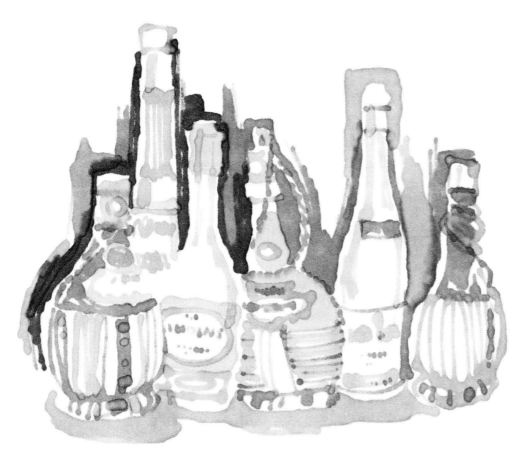

Wine Bottles. *Reverse drawing using marker grays 2 through 8 on 8" × 10" handmade Japanese paper. The shapes of the bottles were silhouetted first in gray to establish a pattern. A simple treatment for the labels, reflections, and wicker baskets finishes the sketch.*

Girl-Watchers. *(Below) Reverse drawing using a fine-line Magic Marker on 11" × 14" sketchbook paper. A loose treatment was used for the figures, with a few touches of gray for accents. Flo-Master cleanser was used to soften the lines.*

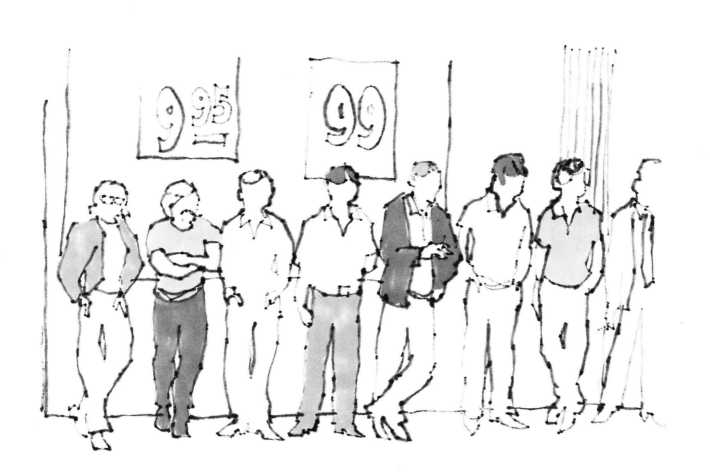

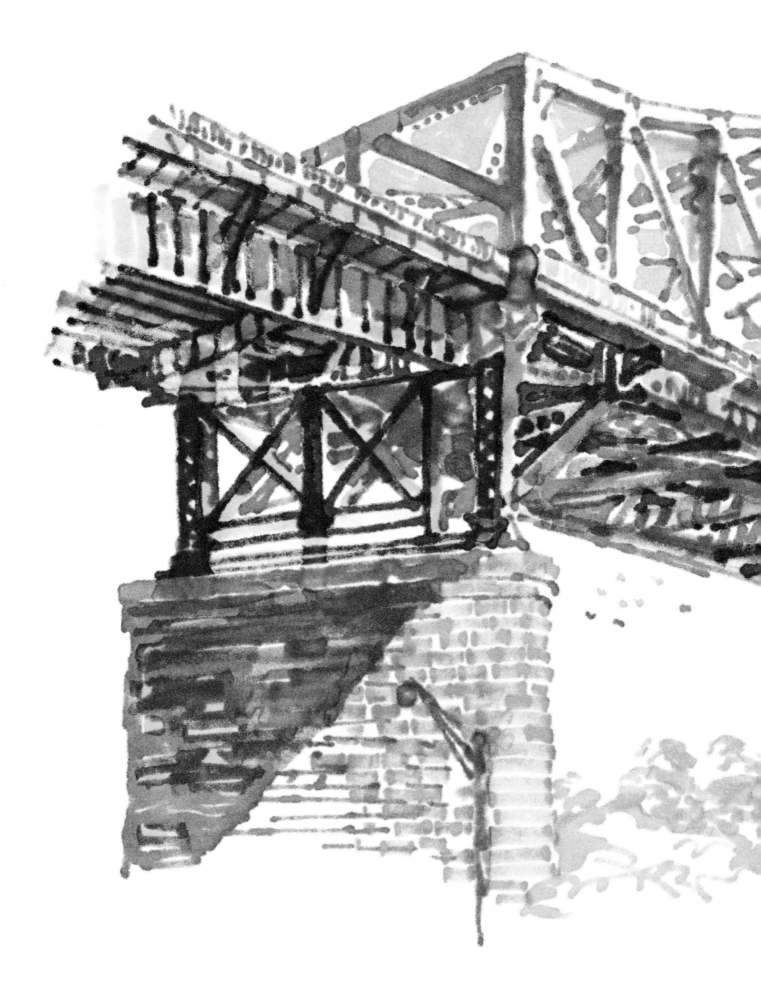

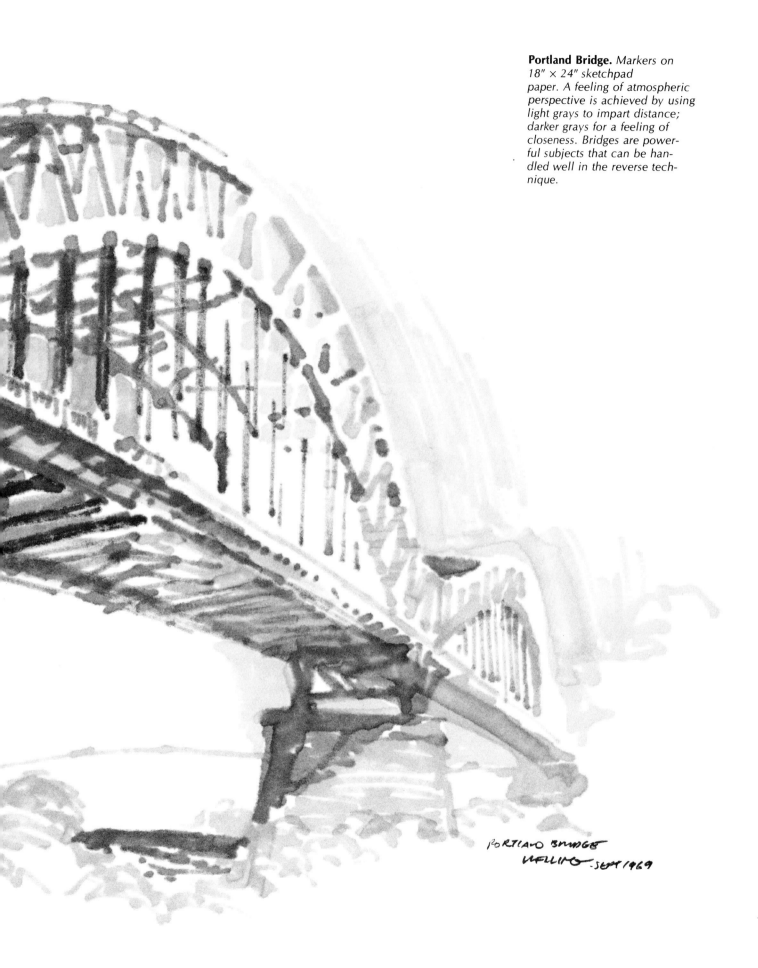

Portland Bridge. *Markers on 18" × 24" sketchpad paper. A feeling of atmospheric perspective is achieved by using light grays to impart distance; darker grays for a feeling of closeness. Bridges are powerful subjects that can be handled well in the reverse technique.*

PORTLAND BRIDGE
WELLING-SEPT 1969

Connecticut Barns. *Reverse drawing using marker grays 2, 4, and 6 on 11" × 14" sketchbook paper. Three values of gray were used to establish a feeling of sunlight coming from the upper left. Remember, when drawing in reverse all your tones will appear slightly lighter as they bleed through the paper. This drawing could have been stronger had I used grays 3, 5, and 7.*

Stonington Docks. *Reverse drawing and markers on 11" × 14" sketchbook paper. Notice how your eye travels right over the boat in the foreground to the tone areas. Make your tones work for you no matter what your technique. Some Flo-Master cleanser has been used to spice up the lines.*

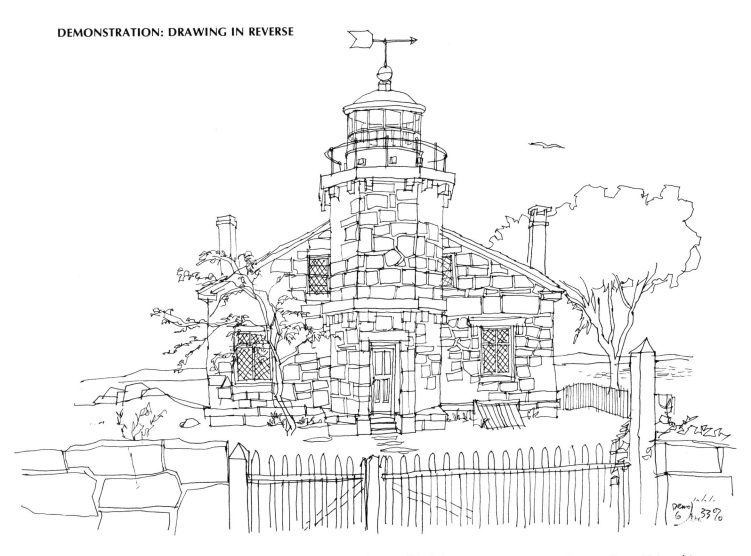

Step 1. Here is my detailed line drawing of a small lighthouse in Stonington, Connecticut. Using this as my guide, I'll trace around the parts of the structure with various tones of gray to build a more solid representation.

Step 2. I begin the reverse drawing, done with marker grays on 15″ × 20″ Toronoko paper, a very soft Japanese paper that's excellent for reverse drawing. With a No. 2 gray, I indicate some of the sky and silhouette the roofline. No. 4 gray is fine for the grass and a No. 3 tone works nicely for the sunlit side of the octagonal stone tower.

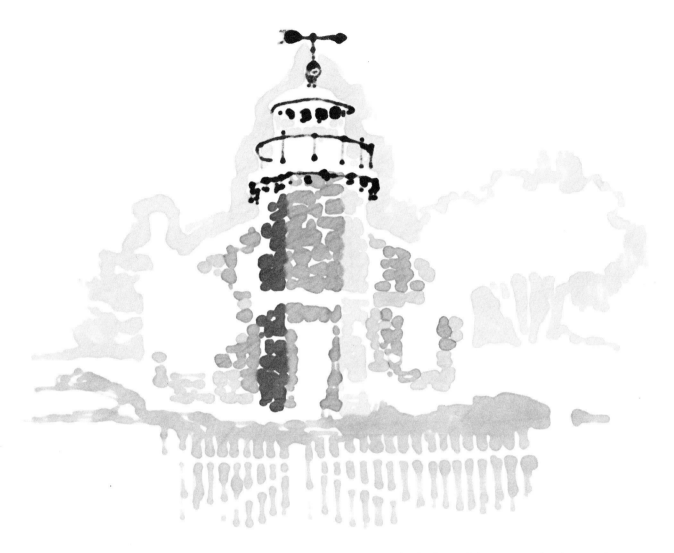

Step 3. Grays 3, 5, and 7, finish the stone tower. Notice the feeling of dimension the three values give to the three sides. The weathervane and some of the details at the top are drawn with a No. 9 gray.

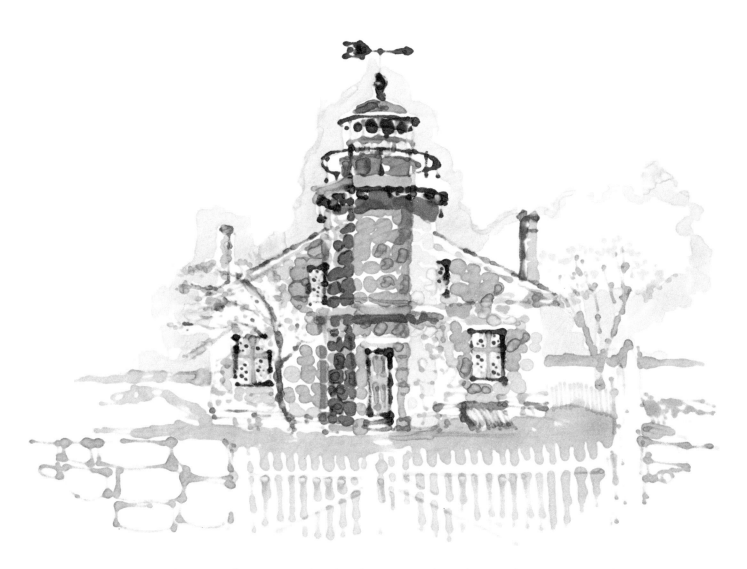

Step 4: Reverse Drawing. Everything is completed at this stage and I've loosened up my tone work with the application of Flo-Master cleanser. This fluid is fine for softening edges and darkening areas where color hasn't penetrated full strength. Use it sparingly; a few accents are all that's required.

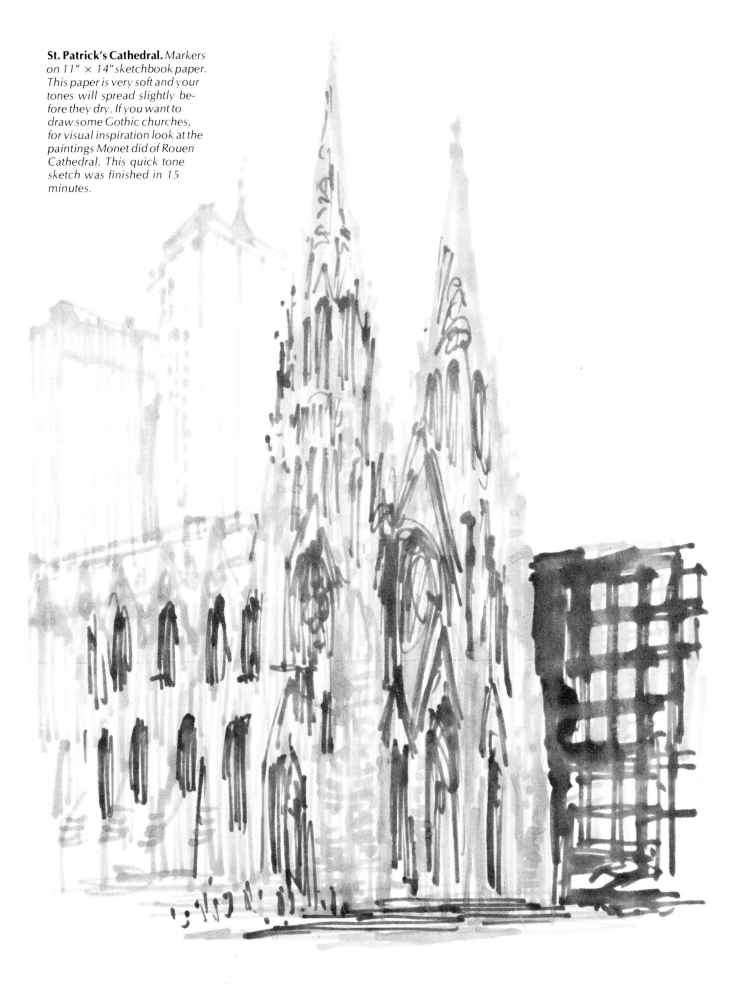

St. Patrick's Cathedral. *Markers on 11″ × 14″ sketchbook paper. This paper is very soft and your tones will spread slightly before they dry. If you want to draw some Gothic churches, for visual inspiration look at the paintings Monet did of Rouen Cathedral. This quick tone sketch was finished in 15 minutes.*

7
PAPER

Paper is your one expendable item. In the long run it's the least expensive of your materials, so don't get hung up on trying to save a drawing that's going badly. Rip out the sheet and start over.

SOFT-SURFACED PAPER

The type of paper found in spiral-bound sketchpads and bound sketchbooks are of the soft variety. By soft, I mean the markers spread slightly as they sink into the surface and bleed through to the other side.

Soft papers are good when you want to fill in areas of flat color with an even tone. The marker ink remains wet enough for you to keep a wet front moving along as you fill in the wash.

Toronoko, a lovely handmade Japanese paper, is wonderfully soft. Despite my opening paragraph about the expendability of paper, I always hate to throw a sheet of this Japanese paper away—it costs about a dollar a sheet!

HARD-SURFACED PAPER

My definition of a hard-surfaced paper is one on which the marker ink doesn't penetrate easily. The Strathmore line of drawing papers is a good example of this type of stock.

Strathmore paper comes in various plys, or thicknesses. The two-ply, medium surface is a fine paper to work on. It is very white, which adds brilliance to your colors.

Colors dry very fast on hard-surfaced paper, which could make it difficult for you to get a flat, even tone.

TEXTURED PAPER

This type of paper has a rough surface, a texture that is often referred to as the "tooth" of the paper.

A good example of textured paper would be rough-surfaced watercolor paper of about 140 pound weight. If you try some sketches on this type of stock you'll find that the hills and valleys that make up the surface create minute white flecks in your tones, colors, and lines that add a sparkle to your drawing.

Don't press down too hard or you'll defeat the purpose of the rough surface. Practice to see just how much pressure you have to apply to get the effect you're after.

COLORED PAPER

Heavyweight pastel paper is ideal for marker drawings. The range of colors is more than adequate, and some very lovely shades are available. There is a nice range of values in gray, too, ranging from light to dark.

You might like to try an all-gray tone drawing on gray paper, using the value of the paper as part of your sketch (such as in the sky or in part of your foreground).

Have a few sheets of colored paper on hand so you can try something different when the mood strikes you.

USE THE PAPER YOU LIKE

You may develop a preference for one type of paper. This is good. The less selecting you have to do before you begin drawing the better. You'll have enough to think about every time you start a drawing, so try to keep your supplies simple. Do use a fairly good grade of paper, though. Some of the cheaper brands will yellow slightly in time, and this will affect the colors in your drawing.

Williamsburg Bridge. *Markers on 12" × 16" gray paper. Grays 4, 6, and 8 were used to achieve a bold silhouette of this East River bridge. Gray paper has a killing effect on your gray markers so you have to use darker tones to get the same impact white paper would give you. The designer of this bridge must have had an Erector set when he was a boy!*

Seaplane. *Pentel and markers on 10" × 16" 2-ply medium-surface Strathmore paper. Markers don't spread on hard-surface paper so use it if you want to maintain a sketchy look in your drawing. Tones on hard-surface paper appear lighter, so you have to use darker-value markers to create your effect.*

Beachcomber Hat. *Marsh felt pen on 12" × 18" textured paper. A wild subject! A thick and thin line is ideal for this hat and the textured paper adds sparkle to the line. Don't press too hard when using rough-surface paper or you'll fill in all the valleys with ink and your line will lose its zip.*

Step 1. Beginning at the left of my 10″ × 15″ textured paper, I start drawing the first of my two subjects. Some of the basic shapes of the helicopter are drawn with a thin Pentel line, using a very light touch to take advantage of the paper's texture.

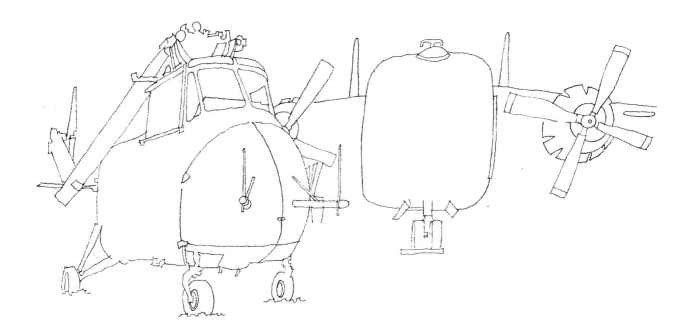

Step 2. My second subject is a big, boxy cargo plane loaded with subtle shapes facing directly at me. More details are added to the helicopter. Try to work on several parts of your drawing at one time to keep from becoming locked in to one portion of it.

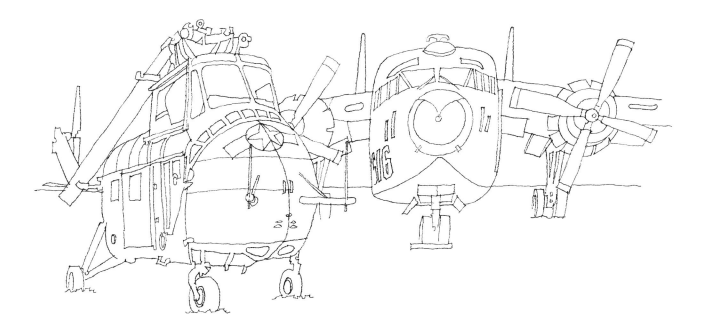

Step 3. This is the almost completed contour sketch. Windows, vents, numbers, and insignia add a nice touch to the aircraft. Proportions of the two planes look good.

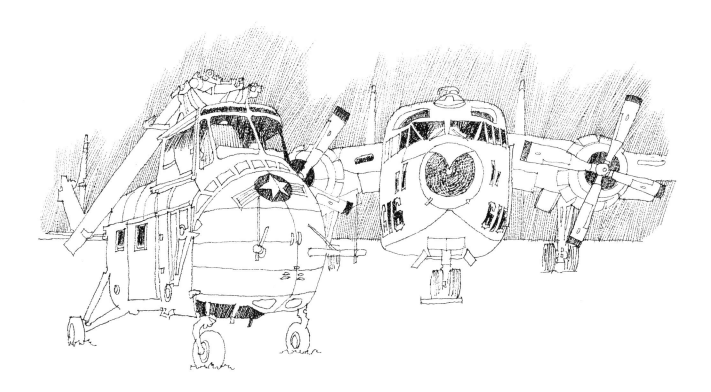

Step 4: Airplane Museum. Amazing what line as tone can do for a sketch! The background tone was drawn in rapidly, with the Pentel held at an angle to the paper to break up the lines more. A few darks for accents finish the drawing.

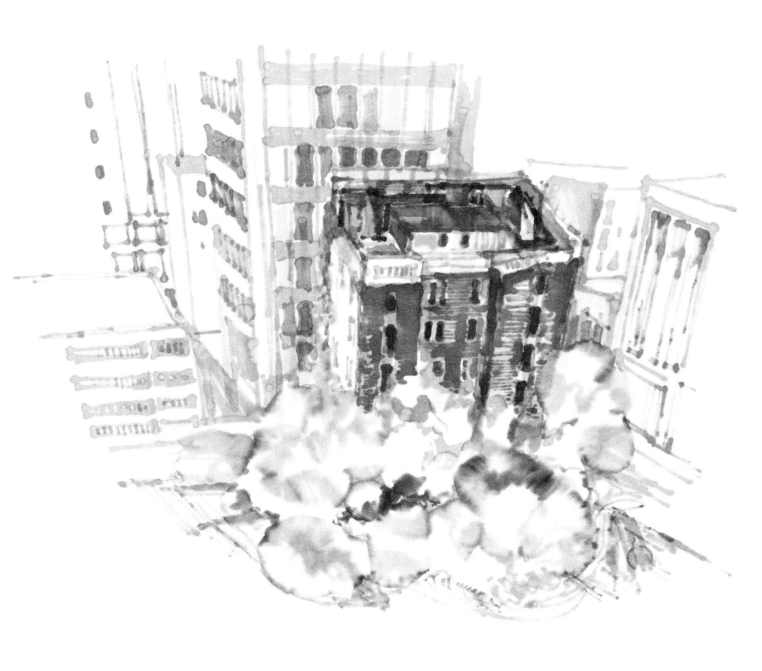

Demolition. *Reverse drawing on 15" × 20" sketchpad paper. Drawn from a photo of a building being demolished with explosives. The cloud effect was achieved by the drip method described in the text.*

8
SOLVENTS

One solvent that can help you loosen up your drawing is Flo-Master fluid, described in Chapter 6, Reverse Drawing. You can also use this drawing tool on your other sketches, not just reverse drawings.

SOFT EDGES

Suppose you want to soften the edge of a tree or some areas of grass or even the side of a building, here's what you do: draw a thin line of cleanser slightly to the outside of the colored area you're working on. The cleanser will penetrate the paper and creep towards the color. When it reaches the marker dye, the color will bleed into the cleanser, lightening and softening the edge.

Experiment on a sheet of sketchpad paper first to get a feel as to how much cleanser to apply. Keep a blotter handy so you can stop the action should you flood on too much cleanser.

DRIP METHOD

The boiling clouds of smoke in the building demolition at the beginning of this chapter were created by the drip method. Some of the major cloud shapes were drawn in with warm grays Nos. 3, 5, and 7 and cleanser was dripped on the sketch as it lay on the floor.

Cleanser was poured a drop at a time from the can from a distance of about four feet. This is a "hit or miss" technique, as it's difficult to predict just what's going to happen as the fluid spreads. When all goes well, some exciting effects can be created.

Work in a ventilated room when using this cleanser, as it has a very strong smell.

OTHER EFFECTS

Other solvents are covered in "Painting With Markers," also published by Watson-Guptill. This is an excellent volume if you'd like to experiment more on your own, but for general-purpose drawing as described in this book, Flo-Master cleanser is all you'll need.

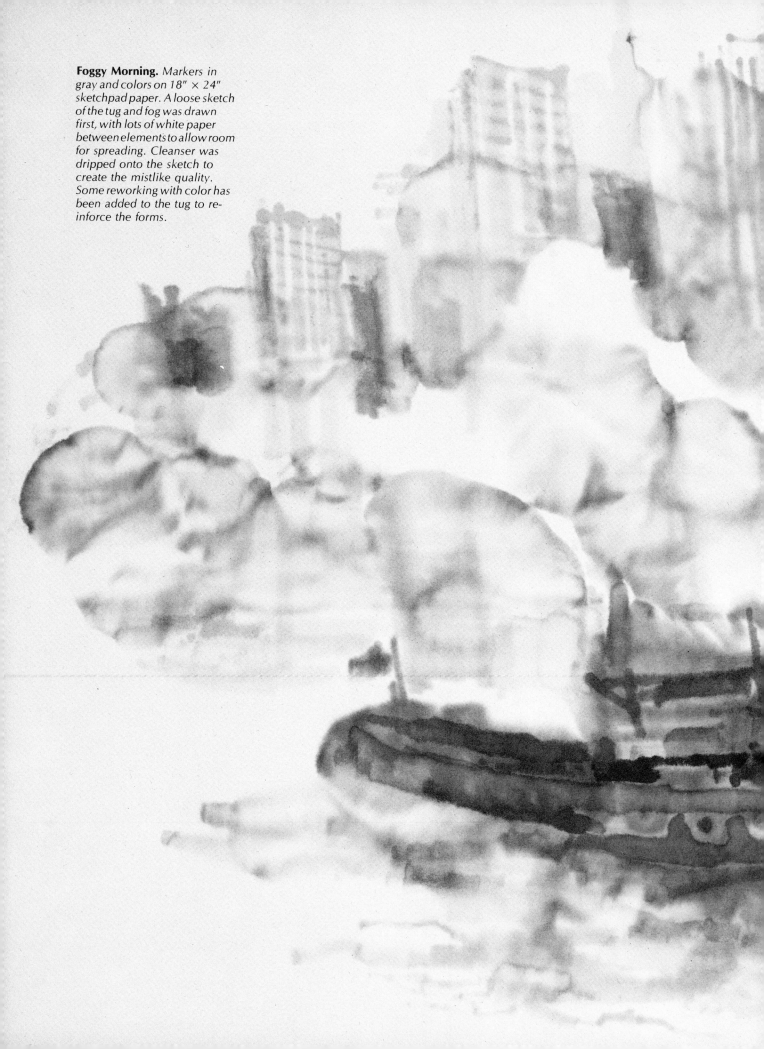

Foggy Morning. *Markers in gray and colors on 18" × 24" sketchpad paper. A loose sketch of the tug and fog was drawn first, with lots of white paper between elements to allow room for spreading. Cleanser was dripped onto the sketch to create the mistlike quality. Some reworking with color has been added to the tug to reinforce the forms.*

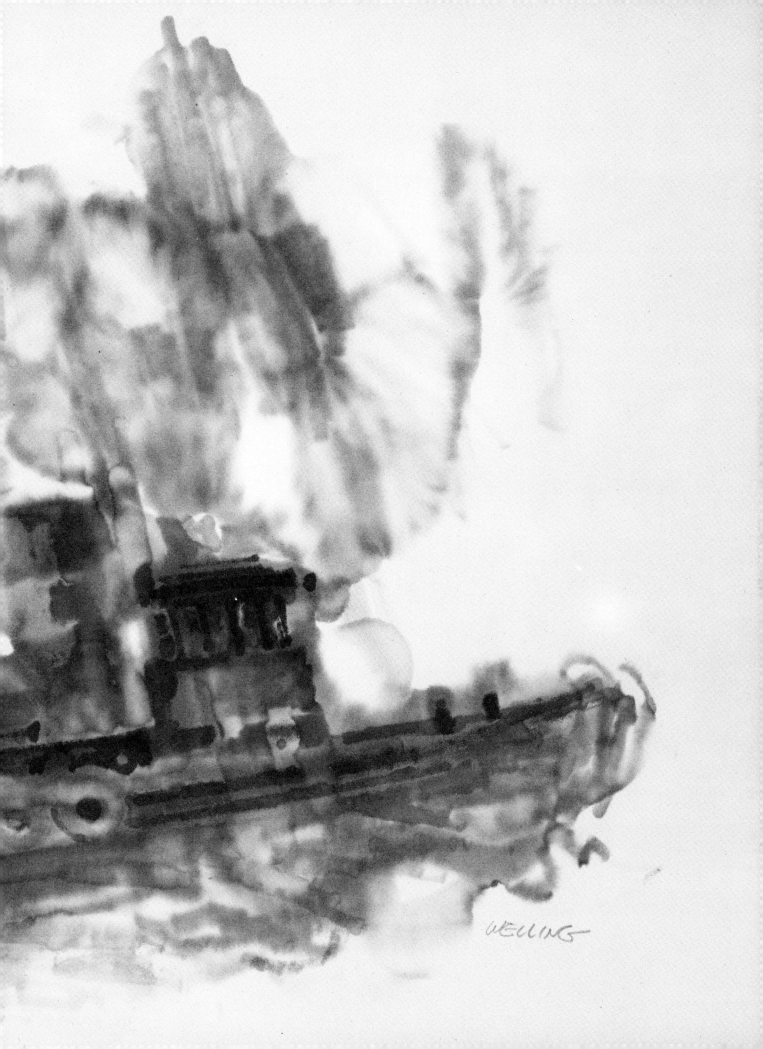

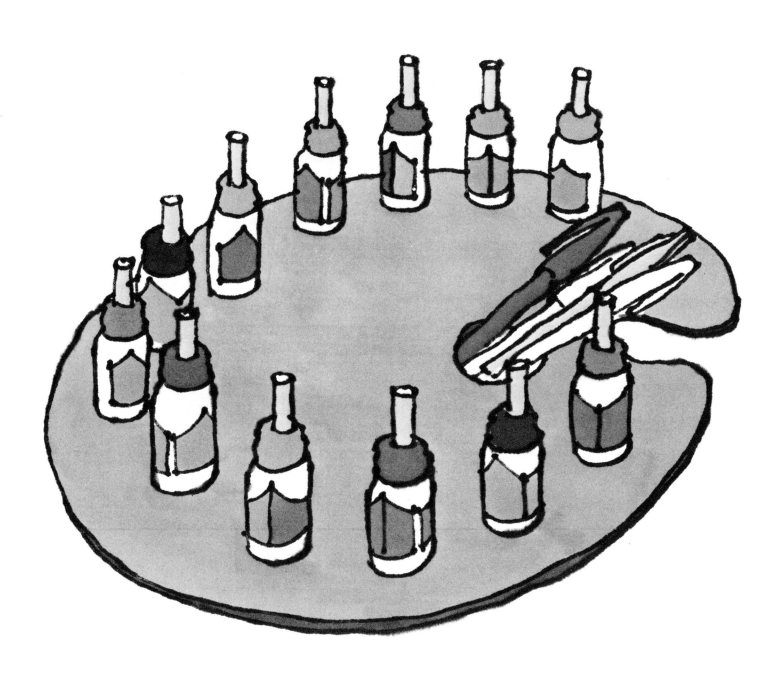

Your marker palette is almost limitless. With a dozen basic colors and a few Pentels you can create splendid color effects.

9
DRAWING IN COLOR

Color is the ultimate expression for the artist. As you get more and more involved in drawing and using color you'll probably find yourself developing a very personal feeling in your work. You may lean toward muted values or you may go in the other direction and rely on intense, vibrant colors to capture the scene. But whatever your visual taste dictates, I'm sure you'll agree that using color is one of the artist's greatest pleasures.

YOUR PALETTE OF COLORS

A selection of basic colors will put you in good shape for color drawing. I suggest the following list:

Cadmium yellow

Cadmium orange

Cadmium red

Vermilion

Crimson

Nile green

Pale olive

Burnt sienna

Burnt umber

Pale blue

Light blue

Ultramarine

To this group you can add:

Lavender

Violet

Yellow Ochre

A little further on in this chapter I'll talk about special colors for drawing in the city and in the country.

You have to go it alone on a few drawings to see what you can achieve. Markers are very intense, so go easy at first. Of course, all colors can be lowered in intensity with the addition of light gray.

MAKE A COLOR CHART

Before you jump into a color drawing, make a color chart. Take the colors you have on hand and on a sheet of white paper make several ½" squares of each. On top of cadmium yellow add a No. 2 gray and see what happens to the yellow. Now try a No. 3 gray and see how much darker the yellow gets. Do the same with your reds and blues and greens. Sometimes, just a hint of gray to tone down a bright color is all that's needed to make it fit right into your sketch.

File all your observations away for future use or include your color chart in your tote bag of materials so you can refer to it now and then.

With the tremendous array of colors available in markers, you really don't have to do much mixing to make your own shade. You can get almost any color right off your art dealer's shelf. Let's take a look at some of these special colors.

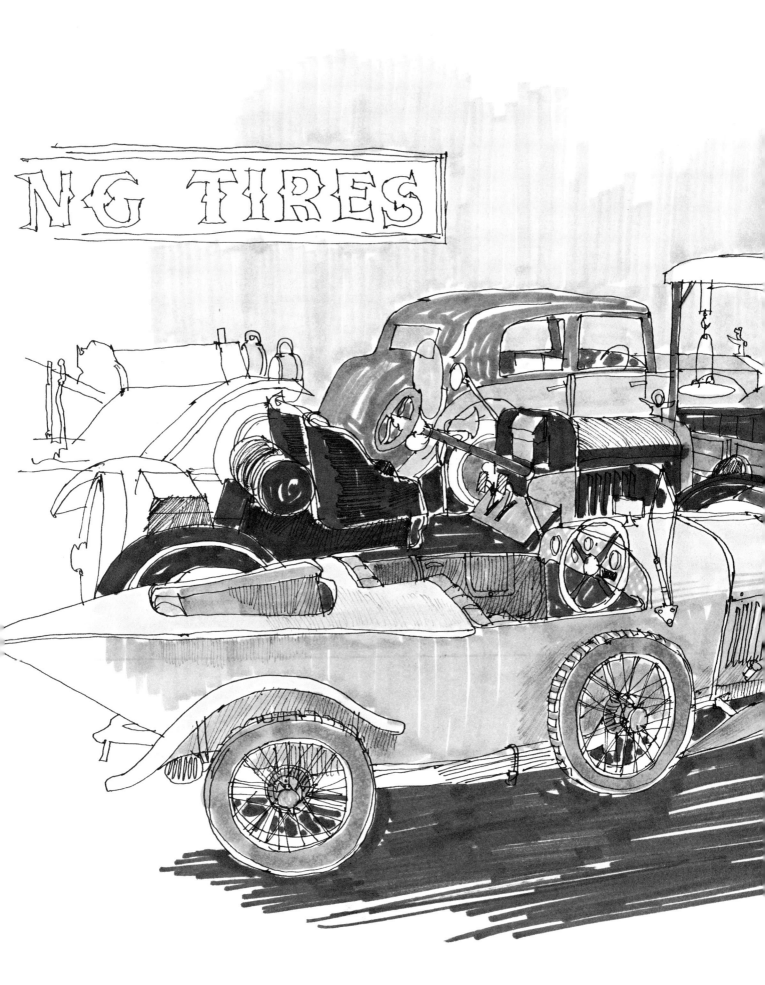

Antique Autos. *Pentel line re-
inforced with marker colors.
Car in the foreground is light
blue, the one behind it is ver-
million, and the Rolls-Royce
against the far wall is two
shades of gray. For another view
of this, see the demonstration
drawings in Chapter 14, Man-
made Objects.*

COLORS IN THE CITY

For your trip downtown take along some of the special Magic Marker colors such as ''putty,'' ''sand,'' ''flesh,'' and ''powder pink.'' The pink is excellent for applying over a light gray to represent pink-colored stone.

''Sand'' is a lovely color to use for light tan-colored buildings. ''Flesh'' is more of a light peach color and is an effective way to warm up the shadow side of a structure. Simply apply it over the gray you have already put down.

Blue-green is a good color to represent the tone of some of the modern glass towers sprouting up in all major cities. Light blue is a good one to use for the lighter-valued glass structures, and if you're interested in doing a night scene, Prussian blue produces a nice dark sky hue.

COLOR IN LANDSCAPES

A selection of greens is a must for landscape work. Nile green, pale olive, and forest green provide a nice range of colors. Blue green works well for reflections in water and for cool green shadows. Brighter greens can be created by putting down a layer of yellow first and then a layer of green over this base.

The warm grays are good for the gray tree trunks, and for old weatherbeaten barns should you chance upon one in your search for subjects.

Interpret nature with a free hand; don't get hung up on matching color for color and you'll have more fun outdoors.

MONOCHROMATIC COLOR DRAWING

As its name implies, monochromatic color means doing a drawing all in one basic color: a night scene in all blues or a landscape in different greens for example. It may sound dull, but you'd be surprised at the lovely drawings you can do by sticking to just one color. Try a subject drawn with a brown line and use various tones of brown for the shading. Monochromatic color is an excellent way to begin to use color.

COLORED PAPER

Here's an area that lends itself to all sorts of possibilities—the only limit being your own imagination. Since markers are transparent, the color of the paper you use will show through to some extent. On a very light-colored paper, your colors will still stay in balance. If you use a paper with a stronger color, then the color of your markers will really be affected and your drawing will break away from a literal translation of the scene.

See the chapter on paper for more information on colored stock.

REMEMBERED COLOR

If you're not in the mood to go out and draw something, then dig out a sketchbook and color in some of your drawings from memory. This is a nice way to loosen up and at the same time learn how to simplify.

Sometimes I'll make a few marginal notes about the colors in the scene: I find these a big help if I want to develop the sketch further.

SIMPLE USE OF COLOR

You don't have to throw color all over your paper to have a colorful drawing. Sometimes the simpler the statement, the more forceful it is! Keep your range of colors simple so your drawing doesn't become overworked. Put your color where you feel it will do the most good.

LET YOUR FEELINGS ENTER IN

After you become more experienced in the use of color, you may find yourself making subtle changes in the scene you're drawing. This is good. Your own feelings should enter your work so that a personal treatment of color will emerge.

Adapt and adjust some of the colors in your drawing. Remember, though, to think your changes out carefully so you don't add a jarring note to the composition—unless of course this is what you have in mind.

ATMOSPHERIC PERSPECTIVE

The effect of colors appearing lighter to us the farther away they are is often called atmospheric perspective. A correct use of this visual phenomenon will add a feeling of depth to your drawings. For example, grass that is in the foreground will look very green, that patch of grass half a mile away is not as intense in color, and those grassy hills a few miles away might appear quite bluish.

As long as you understand this principle you can adapt it to your own purpose. You don't have to match color for color so long as you use a lighter, grayer color for distant objects.

Hold your viewfinder up to a landscape and you'll get a vivid impression of this dropping-off of color intensity as objects recede from you.

WAY-OUT COLOR

There are no rules for drawing and, as in fashion, there are no rules governing the use of color—except common sense. But a misuse of color will stand out quicker than poor drawing.

You might like to try an intense sunset on pink paper using reds and lavender. This combination could work for a nightclub interior, too.

Do some experimenting on your own to see what you can create.

FLAT COLOR

This is a real fun thing. The idea here is to fill in areas with color, making no attempt at shading; just apply consistent, flat patterns of color. You have to work swiftly so the tone goes on smoothly. The best way is to start in a corner and keep moving a wet edge along. This prevents the color from drying, which often results in a hard edge.

Flat color is very contemporary. Peter Max, the well-known poster artist, makes excellent use of this technique in his work.

Almost any subject lends itself to this style. You just have to have patience in filling in all the areas. Your end result will be more of a design than a realistic treatment.

WARM AND COOL COLORS

Along with atmospheric perspective, described earlier, another visual phenomenon that artists have relied upon to help achieve depth in their work is the use of warm and cool colors. Stated briefly, warm colors appear close while cool colors appear distant.

This is a basic fact, but you don't have to stick to it for all your drawing. A landscape drawn entirely with warm tones might appear a little flat, but that might be the effect you're after. If extreme depth is what you want, use cool colors for distant objects.

SUNLIGHT AND COLOR

When you work outdoors, you'll have to get used to the shifting light and shadow patterns on your subject as the sun moves through the sky.

You'll find that, timewise, things remain pretty stable for about an hour or so. This doesn't seem like a lot of time, but as you learn to pace yourself, depending on subject and technique, you'll find that you can complete a sketch in under an hour!

Sunlight has a very warming effect on colors in the morning and in the evening. Look at the paintings of Edward Hopper for example. He has put this observation to good use in his scenes.

SHADOWS

Shadows are an important element when using color. There's more color in shadows than you might think. Shadows on grass are a dark green; shadows on snow are blue.

The shadow side of a dark building is darker than the shadow side of a light building.

Atmospheric perspective affects shadows, too. They appear lighter the farther away they are. Keep your foreground shadows a little darker. The key word for shadows is "luminous": give them life and color so that they will add to your drawing.

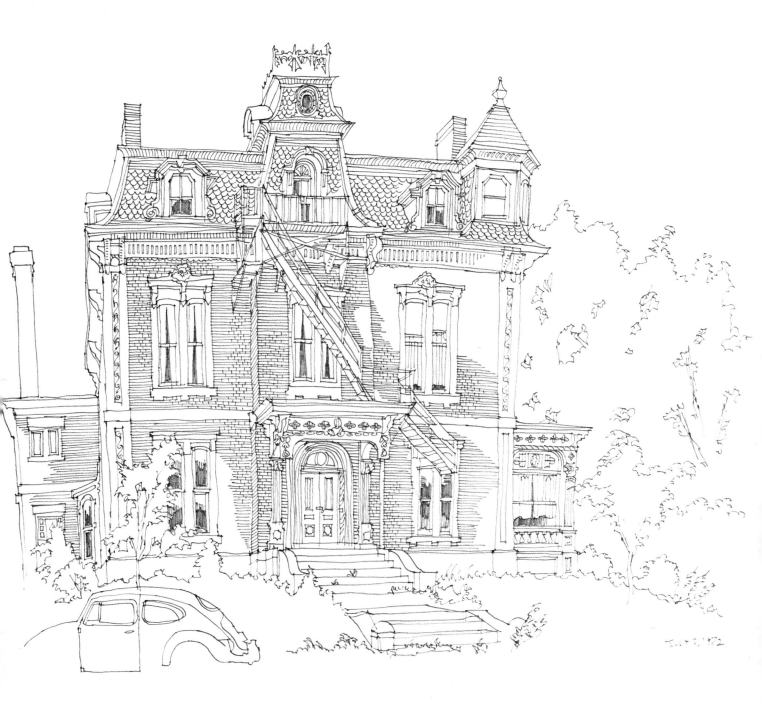

Old House, Portland. *Brown Pentel on 14" × 17" sketchpad paper. A highly detailed study in colored line. Old houses are dandy subjects for your sketchpad. I began this drawing at the roofline and worked down. The "Bug" was included to add a feeling of scale but was simplified so it wouldn't draw attention away from the house.*

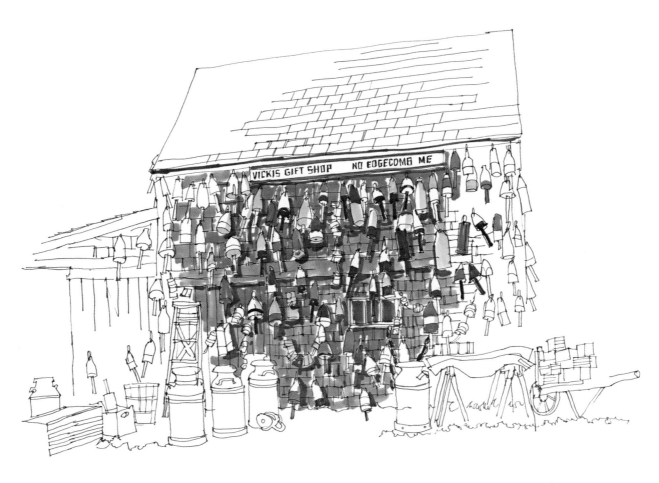

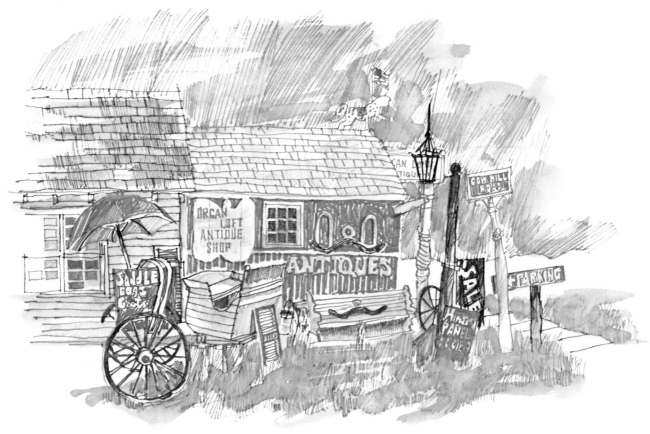

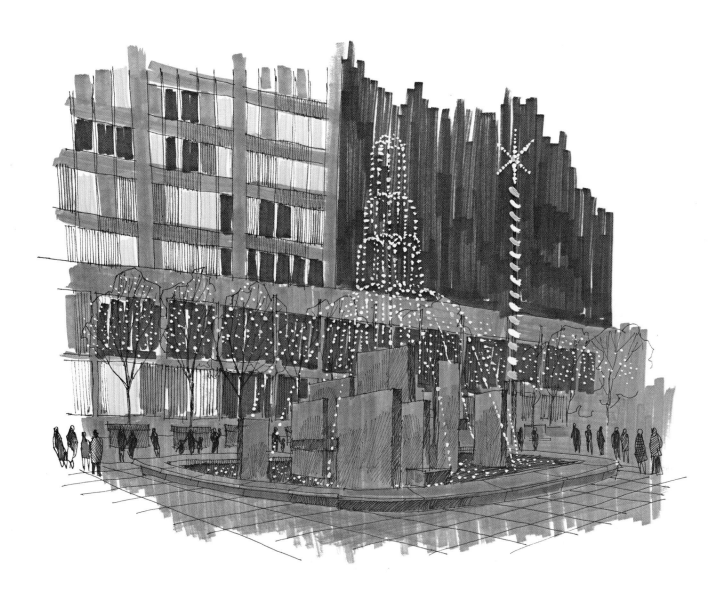

Vicki's Gift Shop. *(Top Left) Pentel and Magic Markers on 14" × 17" sketchpad paper. A No. 5 warm gray acted as a nice background color for the weathered shed without interfering with the colors of the lobster pot buoys. The vignetted colors keep the visual interest in the center of the sketch. Completed in less than an hour.*

Antique Shop. *(Bottom Left) Water-soluble markers on 11" × 14" sketchbook paper. Clear water was brushed over this sketch to give it an almost watercolor look. The water dissolves the marker ink to create the wash tones. A round No. 7 brush was adequate for this small sketch.*

Christmas Lights. *(Above) Blue Pentel and Magic Markers on 15" × 20" sketchpad paper. This drawing was actually made in the daytime and I turned it into a night scene by using a range of blues: Prussian blue, process blue, and light blue. I also used touches of yellow, and spots of white paint for the small lights.*

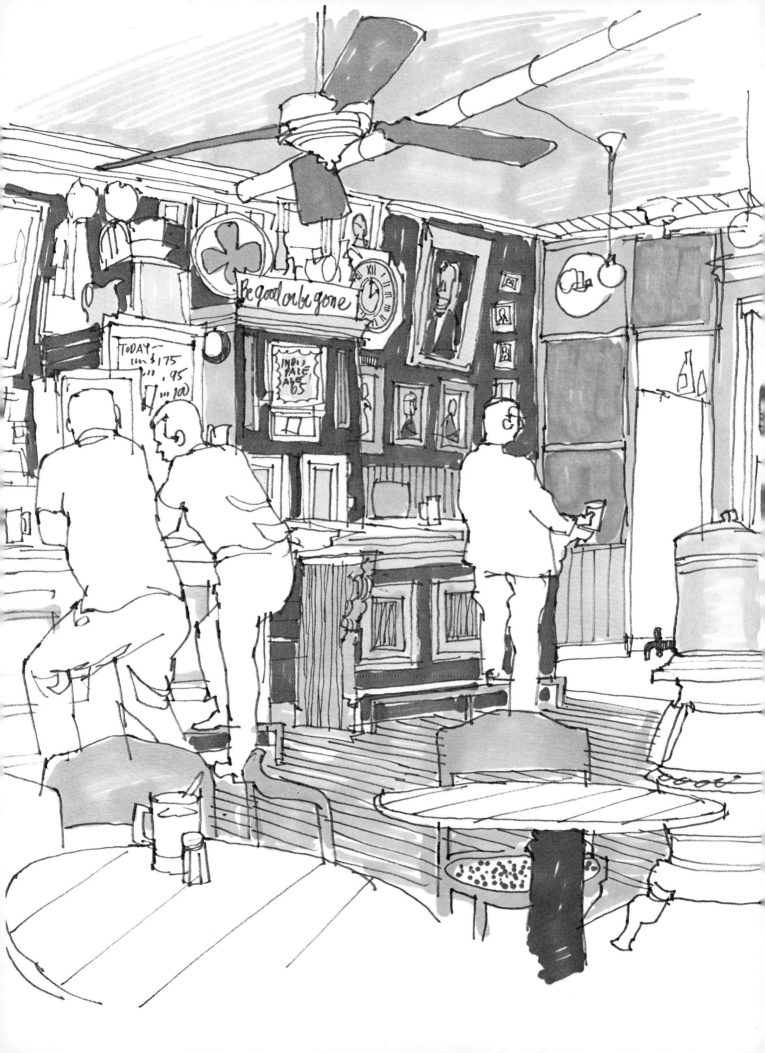

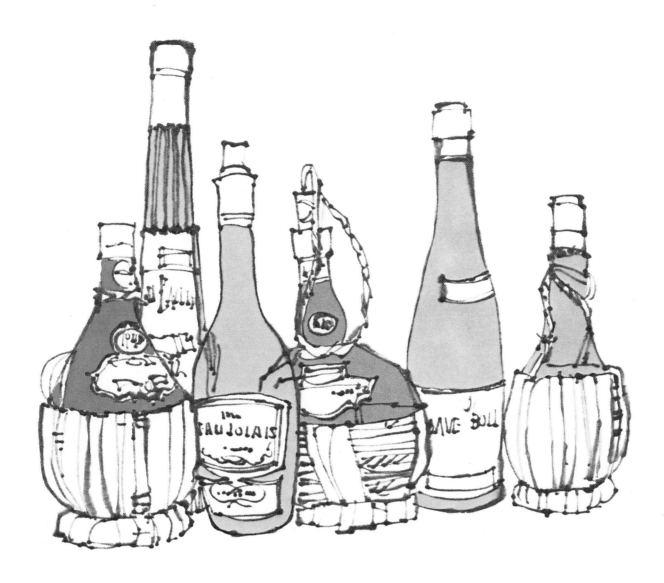

McSorley's Old Ale House. *(Left) Brown Pentel and Magic Markers on 11" × 14" sketchbook paper. I asked permission before starting my sketch and I was so pleased with the outcome that I stayed for lunch. The three figures at the bar impart a nice feeling of scale to the room. The color was done with a free hand rather than in a literal translation of what I saw.*

Wine Bottles. *(Above) Reverse line drawing on 11" × 14" sketchbook paper. Marsh felt pen was used for the line work, Magic Markers for the colors. Flo-Master cleanser was used to soften some of the lines. Flat color areas, with no attempt to capture highlights and shadows, create a clean, crisp feeling.*

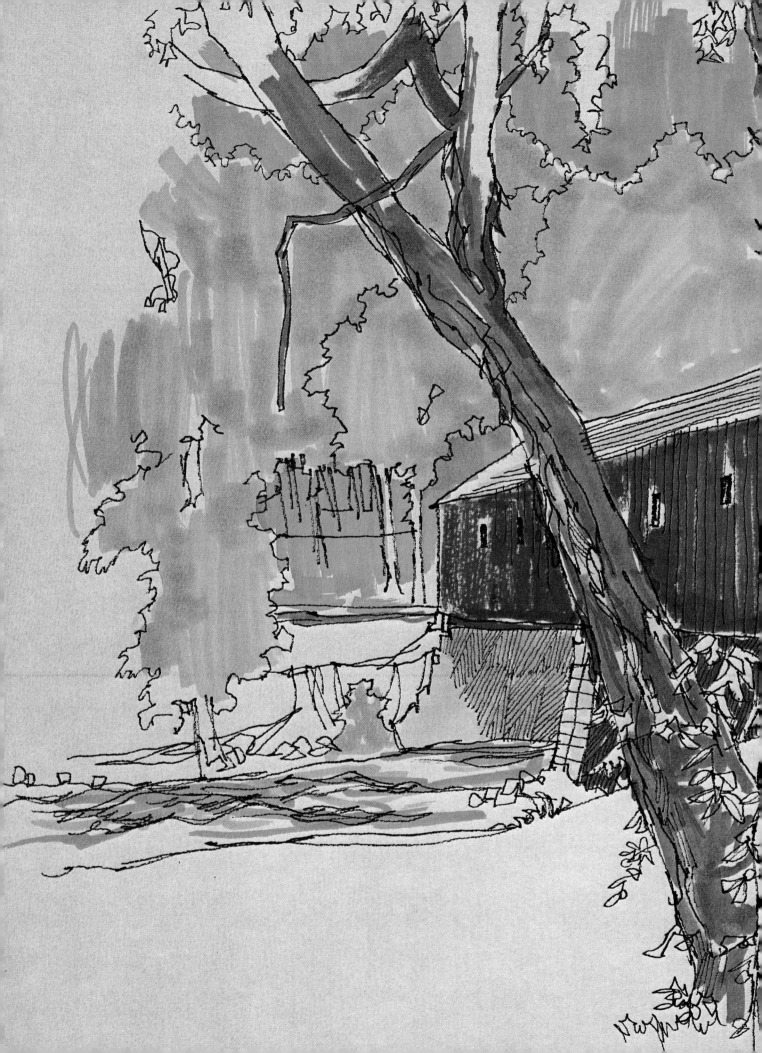

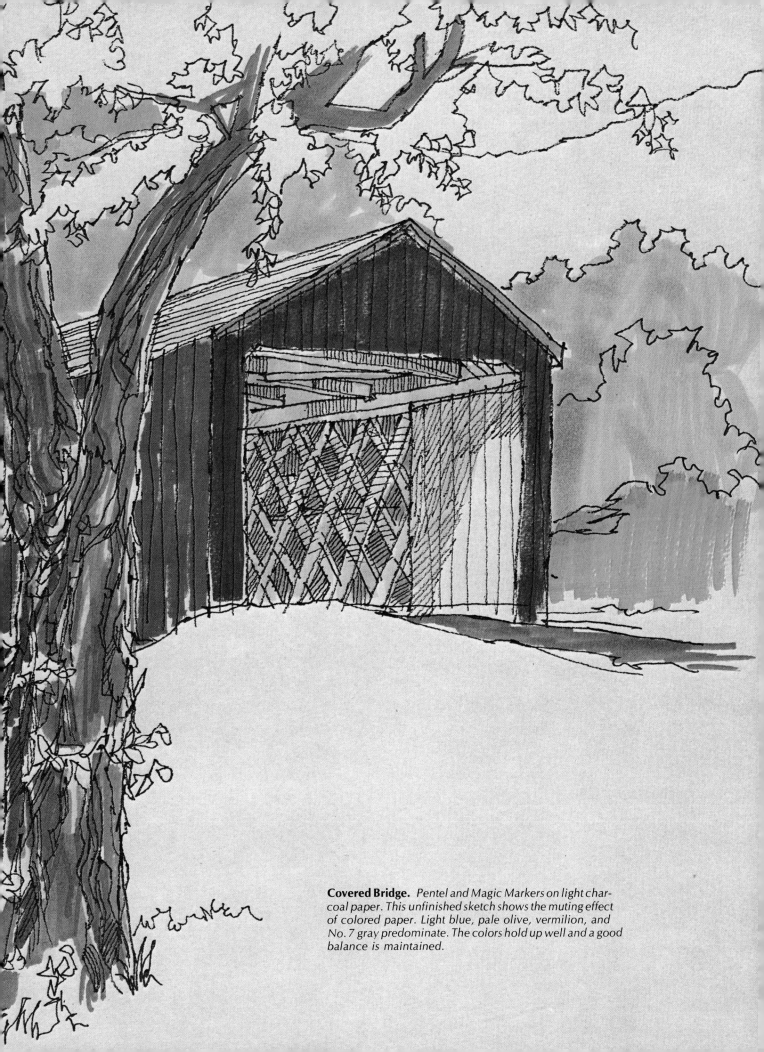

Covered Bridge. *Pentel and Magic Markers on light charcoal paper. This unfinished sketch shows the muting effect of colored paper. Light blue, pale olive, vermilion, and No. 7 gray predominate. The colors hold up well and a good balance is maintained.*

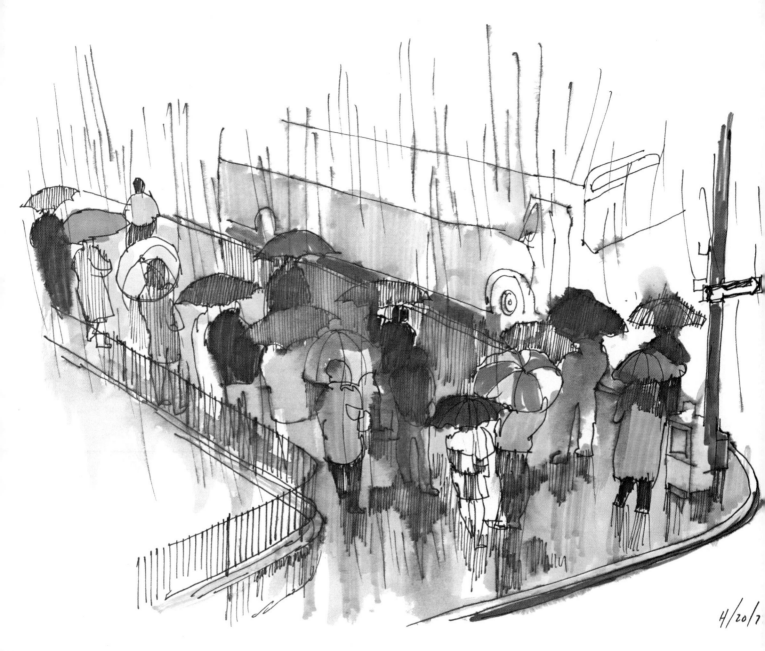

April Showers. *Pentel and Magic Markers on 11" × 14" sketchbook paper. A quick color study of people waiting for a bus done from a fourth-floor window. Clear water was added to a few areas to create wet reflections. Sketch completed in about 25 minutes.*

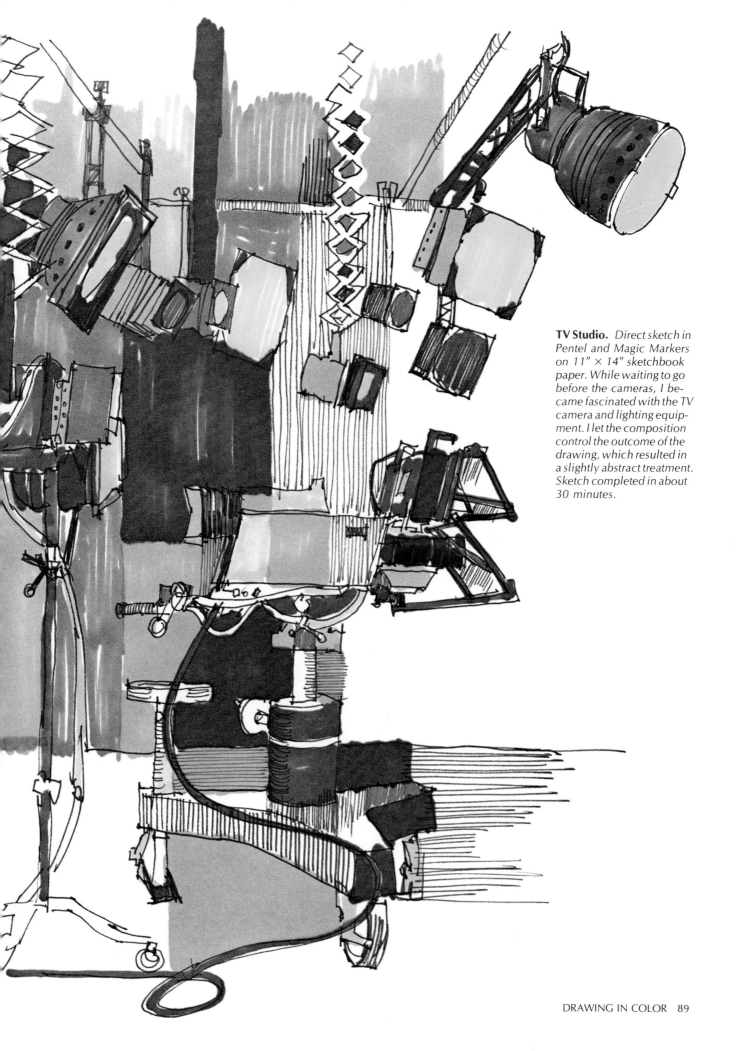

TV Studio. *Direct sketch in Pentel and Magic Markers on 11" × 14" sketchbook paper. While waiting to go before the cameras, I became fascinated with the TV camera and lighting equipment. I let the composition control the outcome of the drawing, which resulted in a slightly abstract treatment. Sketch completed in about 30 minutes.*

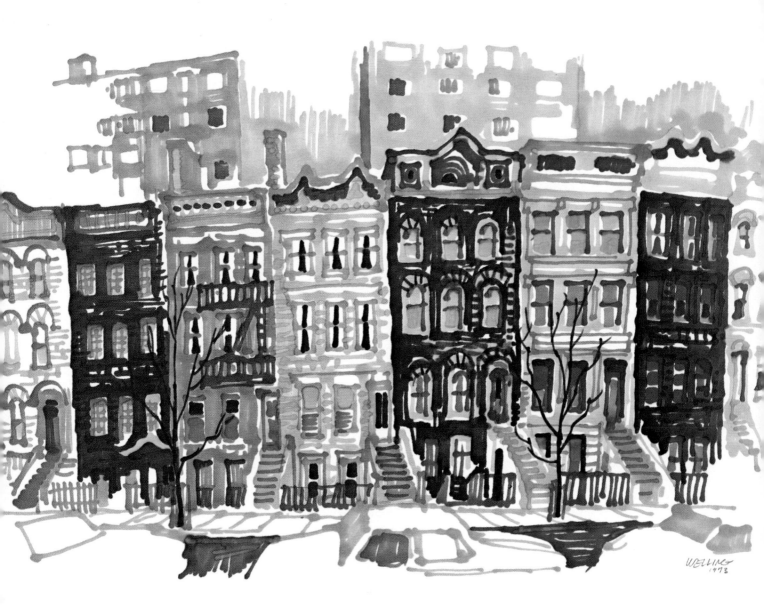

Brownstones. *Magic Markers on 15" × 20" Toronoko paper. Color spreads rapidly on this paper so you have to work fast. A variety of browns and gray tones were used to create this lively view of a portion of West 70th Street, Manhattan.*

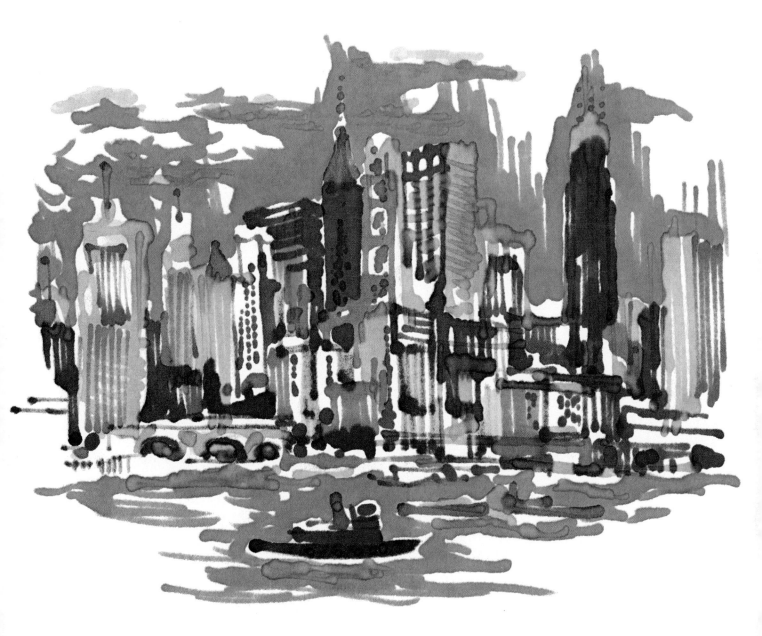

Manhattan. *Reverse drawing on 8" × 10" Japanese sketchpad paper. A good example of simplification. You can't get in much detail on an 8" × 10" sheet, but what you do include had better be good, or else! A nice exercise in visual shorthand.*

Amusement Park. *(Left) Pentel and Magic Markers on 15" × 20" sketchpad paper. This was drawn in the daytime but converted to a night scene by adding a violet sky and adjusting the other colors to fit. Many liberties were taken with the actual colors (the Ferris wheel wasn't red, for example) to create a more striking view.*

Airport. *Location drawing on 11" × 14" sketchbook paper, using Nile green, two blues, gray, and a touch of yellow. A lot of white paper adds to the spacious feeling associated with airports. A good example of a quick sketch.*

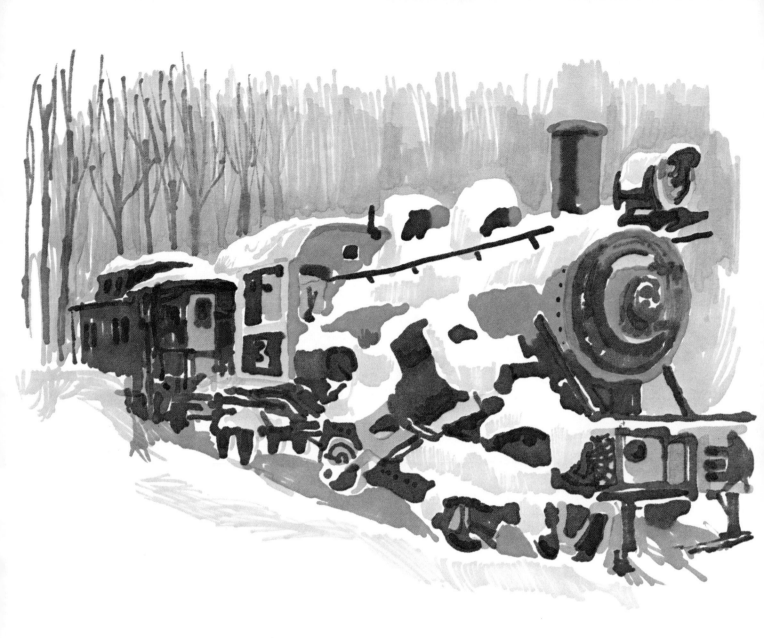

Snowbound. *Reverse drawing on 11" × 14" sketchbook paper. This mood study of an old engine blanketed in snow was redrawn from a line drawing, so I had to rely on memory for the colors. I used Prussian blue, light blue, and shades of brown. The surface of the paper allowed the colors to go on smoothly and evenly.*

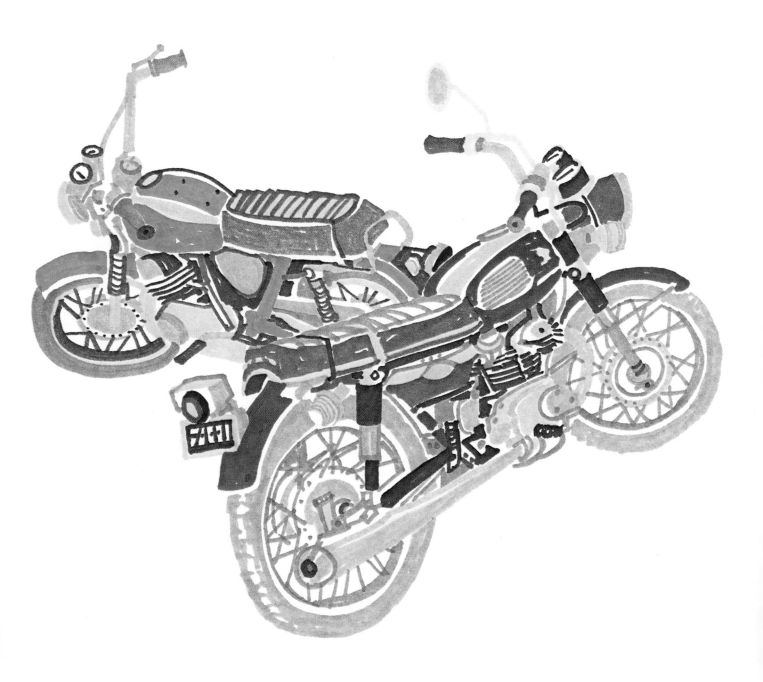

Motorcycles. *Magic Markers on 14" × 14" sketchpad paper. This is a color version of the tone drawing shown on page 51. I used color areas only, with no line drawing, to act as a framework for the tones. Picky details were kept to a minimum because they couldn't be drawn with the wide-tip markers.*

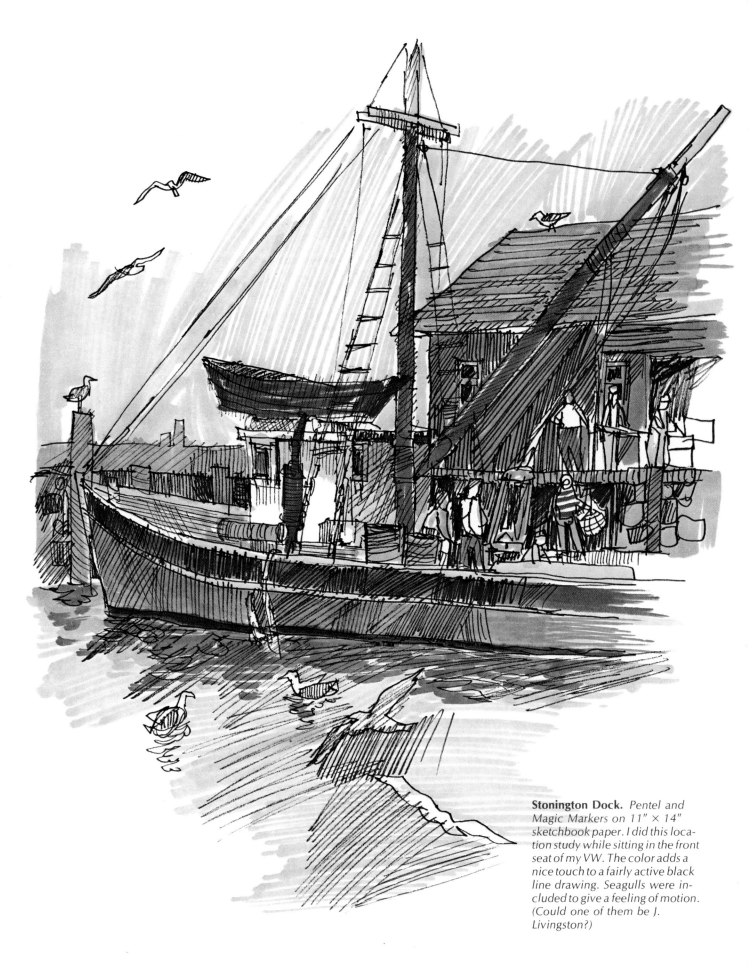

Stonington Dock. *Pentel and Magic Markers on 11" × 14" sketchbook paper. I did this location study while sitting in the front seat of my VW. The color adds a nice touch to a fairly active black line drawing. Seagulls were included to give a feeling of motion. (Could one of them be J. Livingston?)*

10
BOATS AND HARBORS

There's something very appealing to the artist about boats and harbors. The relaxing sound of water gently slapping the side of a boat almost has the rhythm of the human heart. A cluster of sailboats gently rocking to and fro creates a metronome-like composition. You may find yourself becoming so lulled by your nautical subject matter that you won't want to draw anything!

WHERE TO LOOK

If you live on the East Coast or West Coast your only problem is what to draw first! Pleasure craft, sailboats, lighthouses, tugboats, dock scenes—the list of subjects is almost endless. If you live near an inland waterway you can fill your sketchpad with drawings of the vessels that ply these routes. Almost any geographic location has some nautical material. Go out and draw it.

DRAWING BOATS

Boats offer a challenge to you because of their fine proportions and subtle curves. The deck line of most boats is slightly maddening to draw. It dips down, widens out at the middle of the boat, and then curves back in. Before you try a study, practice drawing this curve so you understand just what it's doing.

A small boat can be successfully drawn in profile—even a 100 foot long tug, if you're far enough away to see it all. The hull line is a good place to begin, since it's the longest part of the vessel. Once you get this down on paper you can feel pretty sure that you'll be able to fit the rest in (barring tall masts, that is!).

Ocean liners are exciting to sketch. Don't get too close to the bow or you'll cut off too much of the superstructure. Watch the slight dip in the deckline. If you overdo it your ship may look swaybacked, which is *not* what the ship's designers had in mind!

HARBOR SCENES AND LIGHTHOUSES

Old sheds, docks, jetties, and lighthouses are wonderful marine subjects.

Lobsterpot buoys hanging on the side of a gray, weatherbeaten shed have been drawn a million times, but they do provide a grand color contrast! And a lighthouse, situated on a rocky point, is too good a subject to miss. Draw it in Pentel with some shading and then add clear water for a wash effect.

A harbor scene, with boats riding at anchor, is another worthy subject. Draw just enough water under the boats to establish the surface and leave the rest to the viewer's imagination. It works!

Stacks of lobsterpots and bell buoys lying on their side create nice compositions. Keep your eyes open for unusual subject material; if you find something that excites you, draw it then and there. Don't think to yourself that you'll be back tomorrow—by then it could be gone. Don't take a chance at losing a good drawing.

DRAWING ROCKS

Rocks are tough to draw because of their sharp edges, subtle values, and the confusing shadow patterns that change as the sun moves through the sky. If you try a tone study, plan to finish it in 60 minutes or less. This is about as long as a shadow pattern will remain without severe changes. A rock study on gray paper is a nice change of pace; the color of the paper acts as an overall tone for the rocks and makes it easier for you to comprehend the scene.

A line study of rocks, on the other hand, takes a lot of visual work on your part, and you'll have to use your imagination to finish your drawing. A small cluster of rocks can make a nice composition if you know what to leave out so that just the essentials remain.

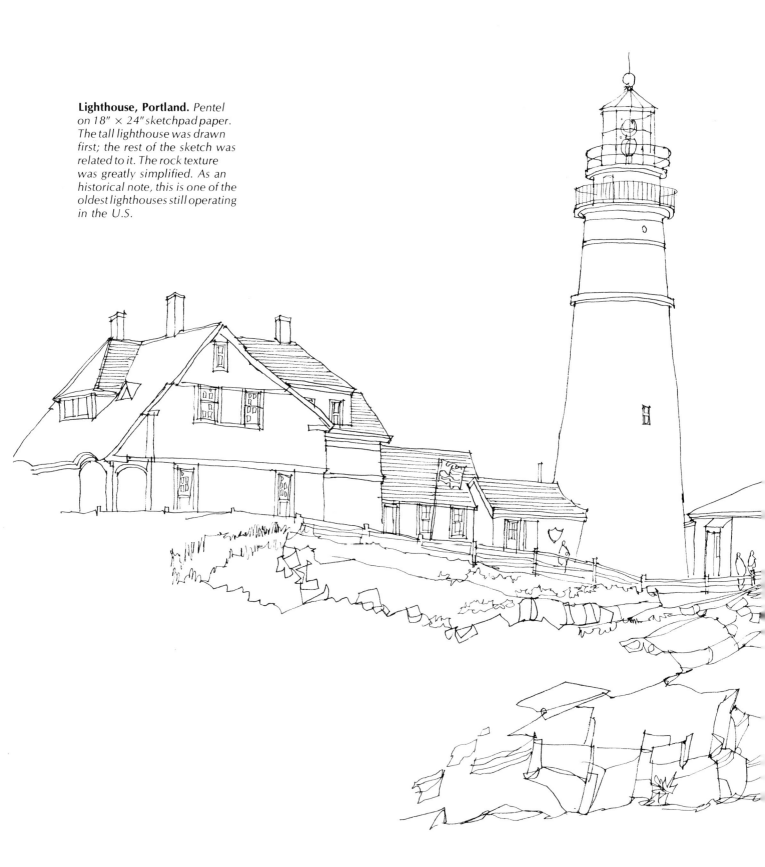

Lighthouse, Portland. *Pentel on 18" × 24" sketchpad paper. The tall lighthouse was drawn first; the rest of the sketch was related to it. The rock texture was greatly simplified. As an historical note, this is one of the oldest lighthouses still operating in the U.S.*

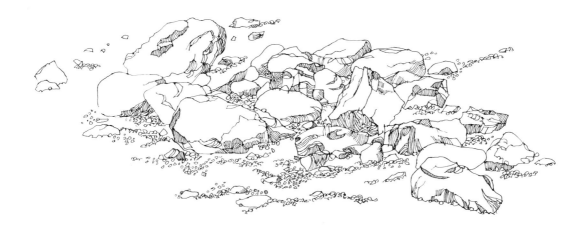

Rock Study. *(Above) Pentel on 14" × 17" sketchpad paper. It has been said that there is a picture no matter where you look. I tried the saying out on these rocks and it worked, but I had to leave out an awful lot and really think through my composition. Shading has been applied where it would do the most good, to emphasize the edges.*

Bell Buoys. *(Right) Pentel on 11" × 14" sketchbook paper. A nice subject to find down by the docks. The nervous line adds a corroded look to the various shapes. A few spots of black help define the three bases and the superstructure. Drawing completed in 20 minutes.*

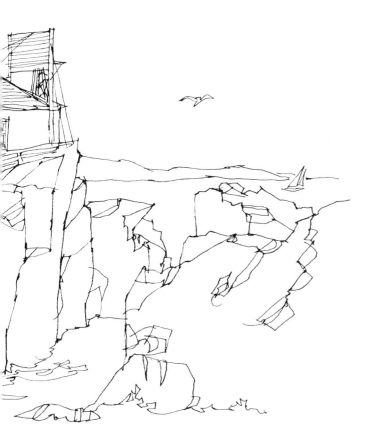

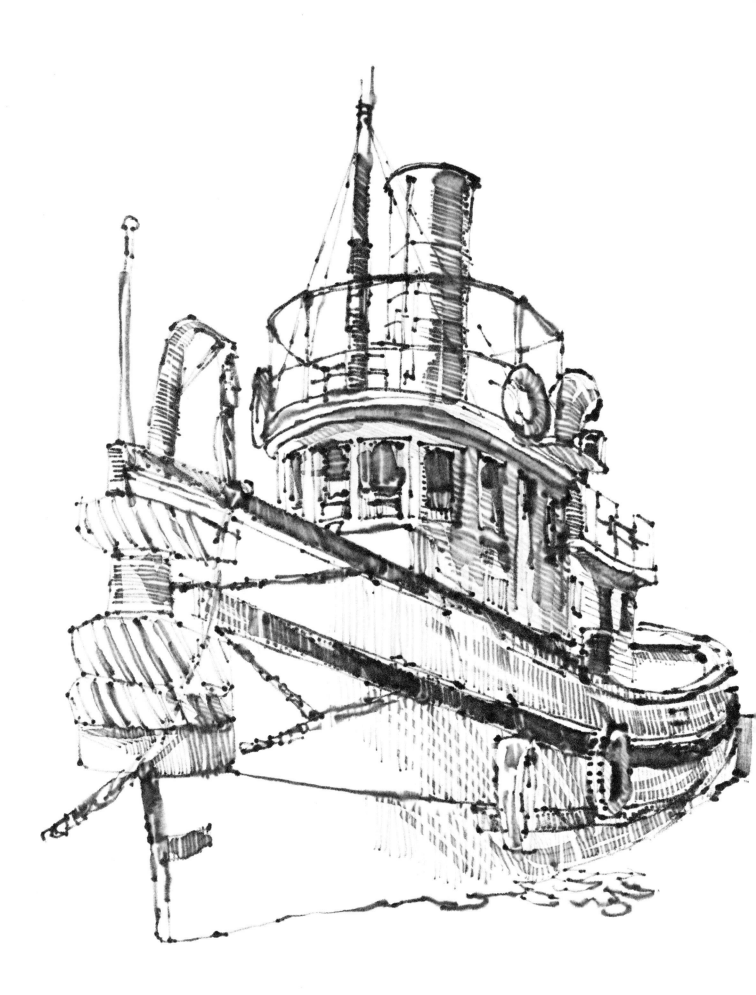

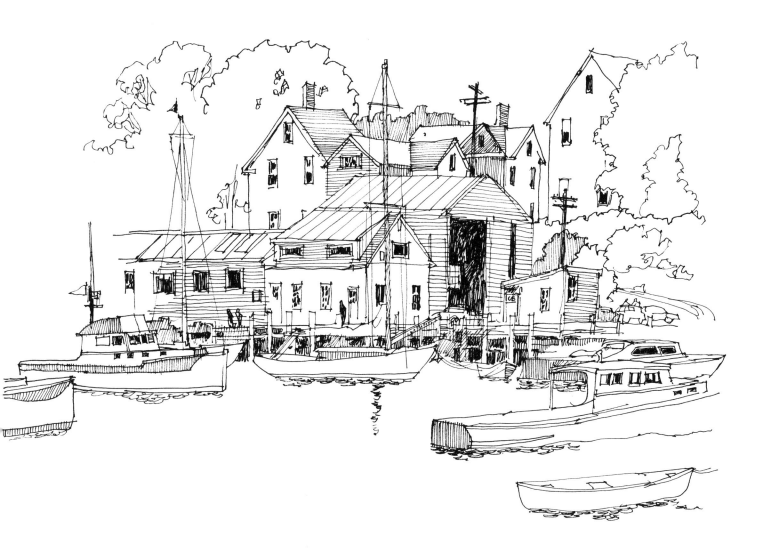

Steam Tug. *(Left) Marsh felt pen on 11″ × 14″ sketchbook paper. This is the reverse side of my sketch, which I thought more interesting. I've used Flo-Master cleanser on several areas to loosen it up. Notice the feeling of reflected light on the hull; the cleanser did this as I drew it through some of my lines on the working side of the sketch.*

Camden Harbor. *(Above) Pentel on 11″ × 14″ sketchbook paper. This cluster of buildings and boats lends itself to a direct-line drawing technique. Shading has been applied to the roofs and hulls to emphasize pattern and form.*

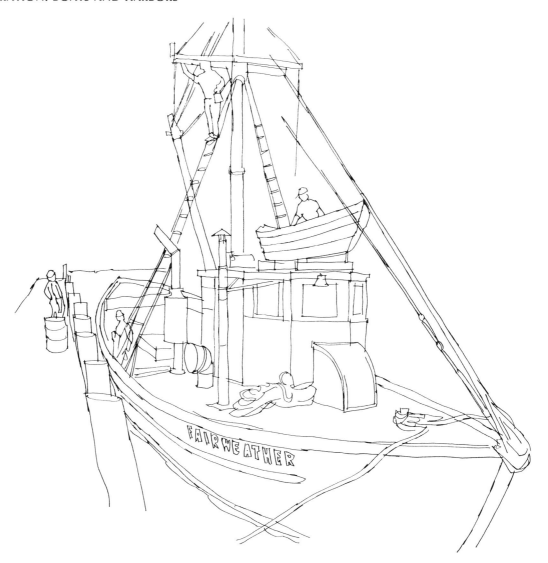

Step 1. Using a Pentel and markers on 15″ × 20″ sketchpad paper, I begin with the nearest boat and draw the mast, the pilothouse, the hull, and an indication of the dock. Even though my line is a little off in places, I've looked very closely at the proportions and shapes of my subject.

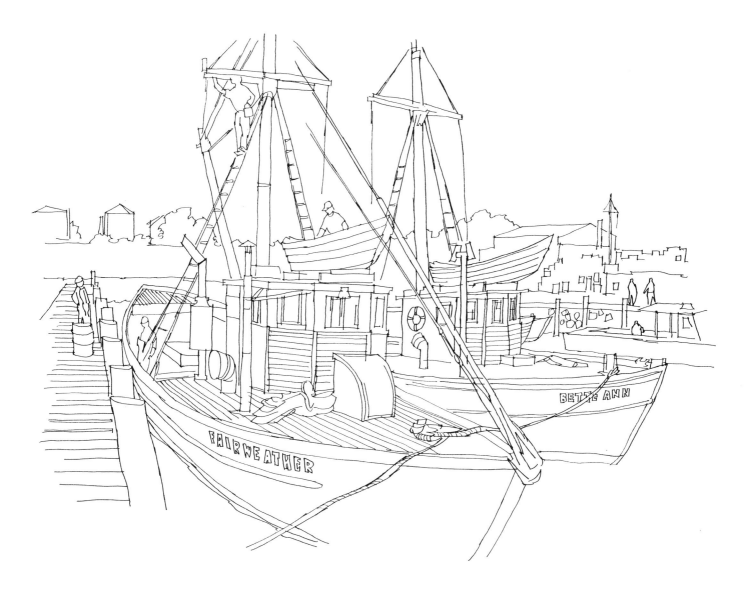

Step 2. I add the second boat, along with the dock at the right and some houses in the background. The drawing as it stands now is a crisp contour sketch and can stand on its own, but let's add some shading for more impact.

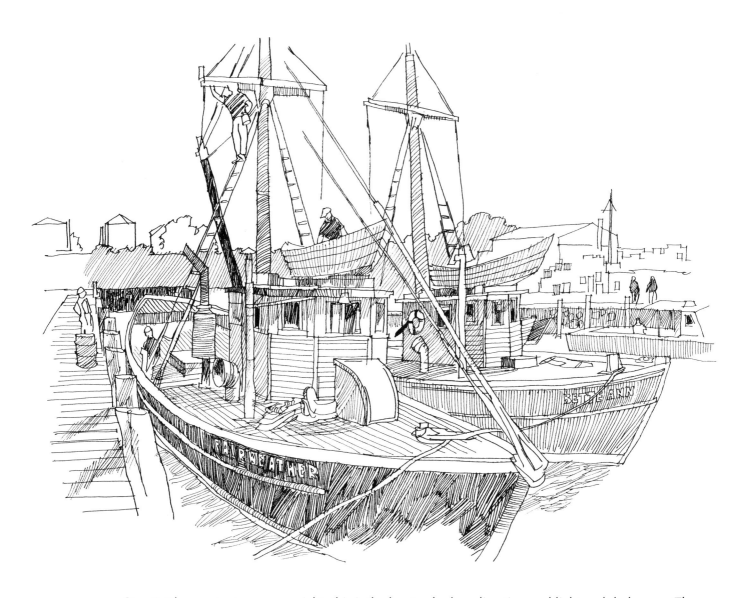

Step 3. The sun is at my upper right; this is the key to shadow direction and light and dark areas. The direction of lines in the shading helps strengthen the forms of the boats. I keep the tones on the light side so that when I add gray tones in the next step, they won't appear too dark.

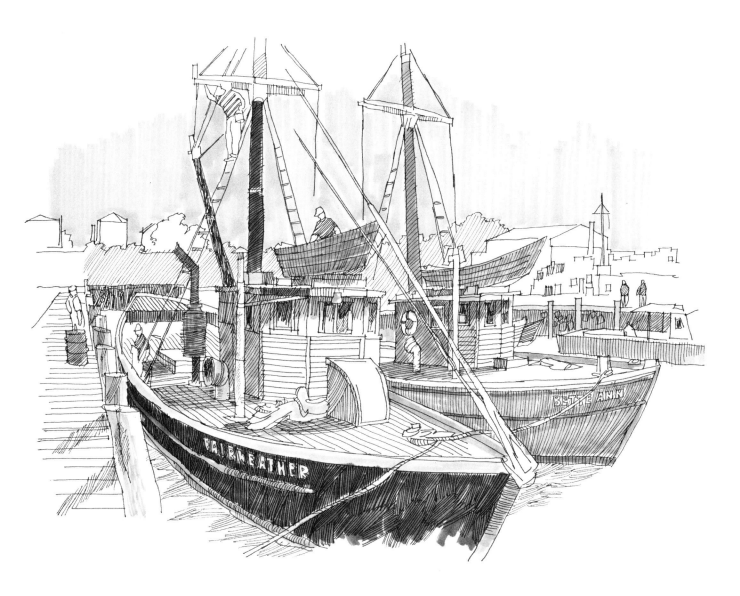

Step 4: Stonington Docks. You must admit that gray tones certainly liven up a drawing. Tones 2 through 6 are used to good advantage. Lots of white paper has been left untouched to add a sunlit effect.

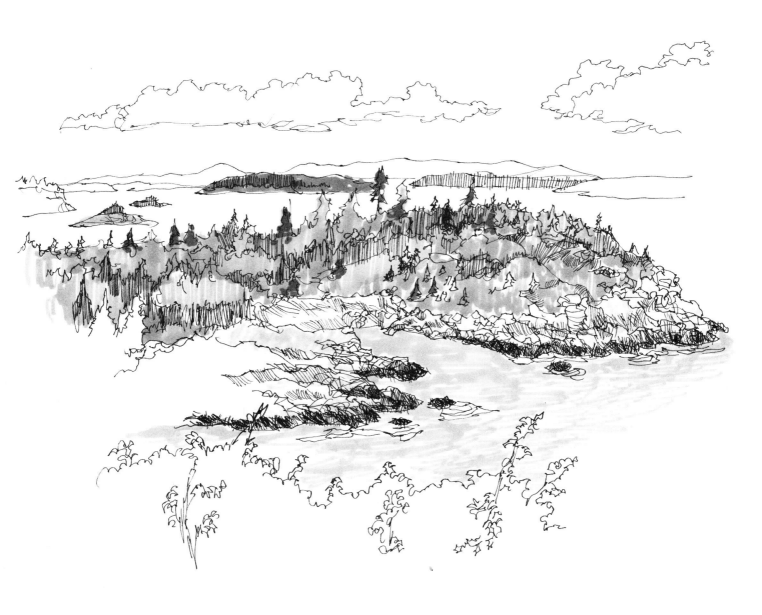

Bar Harbor. *Pentel and markers on 11" × 14" sketchbook paper. A study in texture simplification: rocks, water, trees, and clouds. The heavy use of gray in the foreground creates a center of interest while the contour line used for the clouds puts them way off in the distance where they belong.*

11
LANDSCAPES

If you like being outdoors, rubbing elbows with nature, then drawing landscapes should appeal to you. Their ease of handling makes felt markers ideal companions for a trek in the woods.

START WITH INDIVIDUAL SUBJECTS FIRST

Before you tackle a complex landscape, spend some time drawing individual trees. Draw a half-dozen different types of trees, and try to develop your own technique for drawing leaves and texture. Remember: you don't have to draw a thousand leaves to portray a tree. Study the masses and the clumps and draw them, putting in details only where you think they'll do the most good.

For a real challenge, find a nice shapely tree and draw in as many leaves as you can! It will take you quite some time, but if you use a contour line you won't have to worry about shadows and sunlight and when you're through you'll have a lovely tree study.

LOOK FIRST

The rich variety of subjects supplied by nature may frustrate you at first, so here's a tip: spend a lot of time just looking. Study nature's patterns and colors. Think to yourself, "How would I draw that?" Take your viewfinder along to help you with composition and scale. And when you've charged up your visual battery, release all that energy into your fingertips and draw!

ARCHITECTURE AND LANDSCAPE

Old barns and farmhouses are grand subjects. There are still plenty of these to be found although you may have to drive around a bit to locate one. And when you find a promising scene be sure to ask permission if you're actually on the property. You may be turned down now and then and have to compromise by doing your drawing from the road, but most people are understanding and will let you go ahead with your sketch.

If you live in an industrial area, try some sketches of what's around—steel mills, oil derricks, coal towers, stone crushers, or whatever.

Rusted old farm equipment or abandoned cars can also provide interesting subject matter for your sketchbook. I once came upon an old, rusty truck on—of all places—Bedloes Island where the Statue of Liberty is located!

WINTER SCENES

If you bundle up properly, winter sketching is possible. I can function pretty well down to 35°–40° F., providing there's no wind to increase the chill factor. I'm a New Englander by birth and I'm used to cold winters, and I'll be darned if I'm going to put my markers away during the cold weather! There *is* a limit, though. When you find your markers beginning to freeze, go inside! No drawing in the world is worth catching pneumonia!

You can draw from the front seat of your car and you'll find that the windshield will act like a huge viewfinder. Very efficient.

MARKERS IN YOUR GLOVE COMPARTMENT

Keep a Pentel or two and a few warm gray markers in the glove compartment of your car so that should you chance upon a drawable landscape you'll be prepared. A 9" × 12" spiral-bound sketchpad doesn't take up much room and could be kept in the trunk.

Landscapes are tough (what drawing subject isn't?), but if you enjoy doing them, stick with it until you're doing the type of drawings that please you.

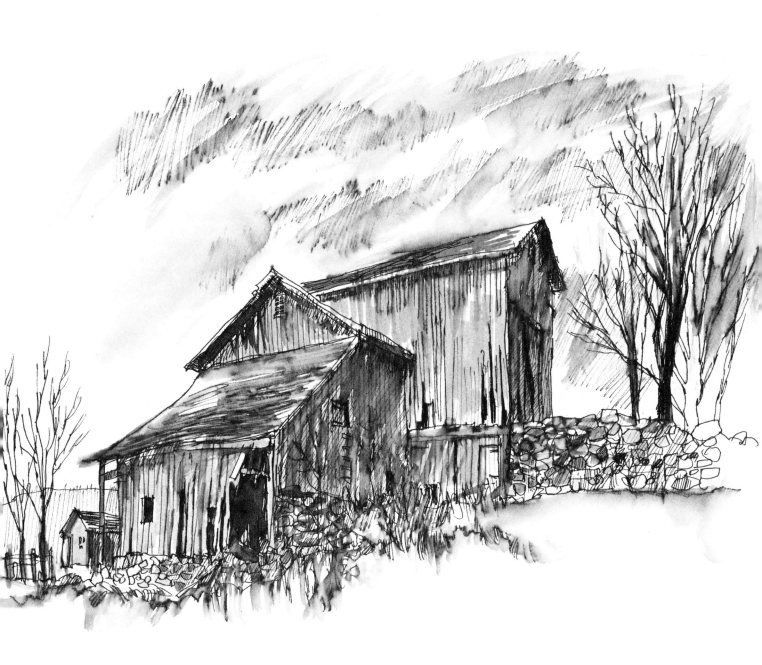

Old Barns. *Pentel wash and markers on 14" × 17" sketchpad paper. Plenty of water was applied to the sky area and the sides of the barn to create bold tones. After the paper dried, gray No. 4 was added to the sunlit sides to impart a weathered look.*

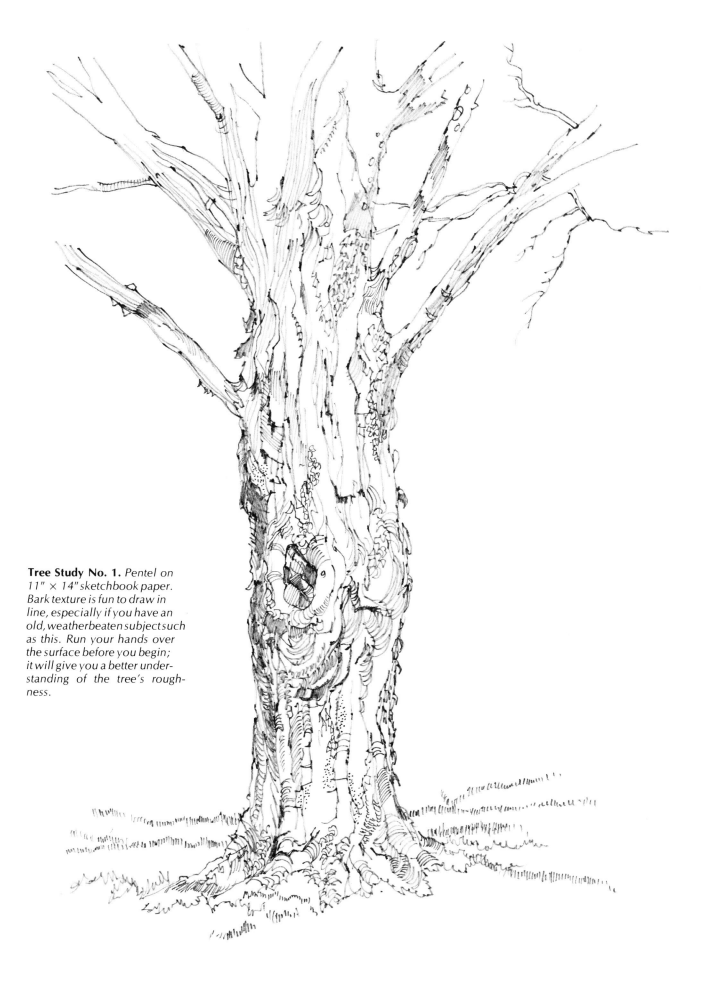

Tree Study No. 1. *Pentel on 11" × 14" sketchbook paper. Bark texture is fun to draw in line, especially if you have an old, weatherbeaten subject such as this. Run your hands over the surface before you begin; it will give you a better understanding of the tree's roughness.*

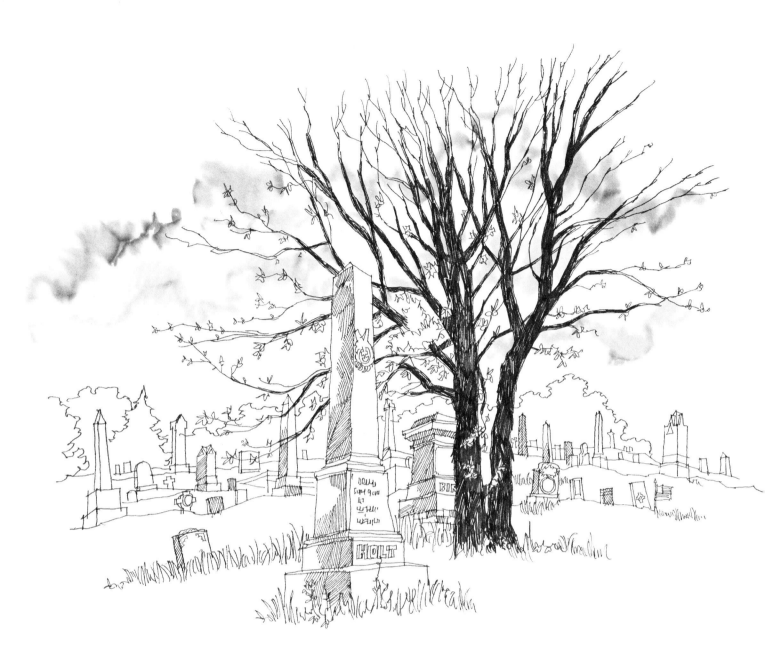

Hilltop Cemetery. (Above) Pentel and markers on 15″ × 20″ sketchpad paper. A mixed technique. The clouds were created by the drip method as described in Chapter 8, Solvents. The trees and tombstones were drawn over this to complete the airy scene. This technique demands control and is best achieved in the studio rather than on location.

Tree Study No. 2. (Right) Pentel and marker gray 3 on 11″ × 14″ sketchbook paper. The line drawing was completed first and then the gray was added. Notice the different values achieved with only one gray. You can do this by letting the color saturate the paper in some spots, not as much in others.

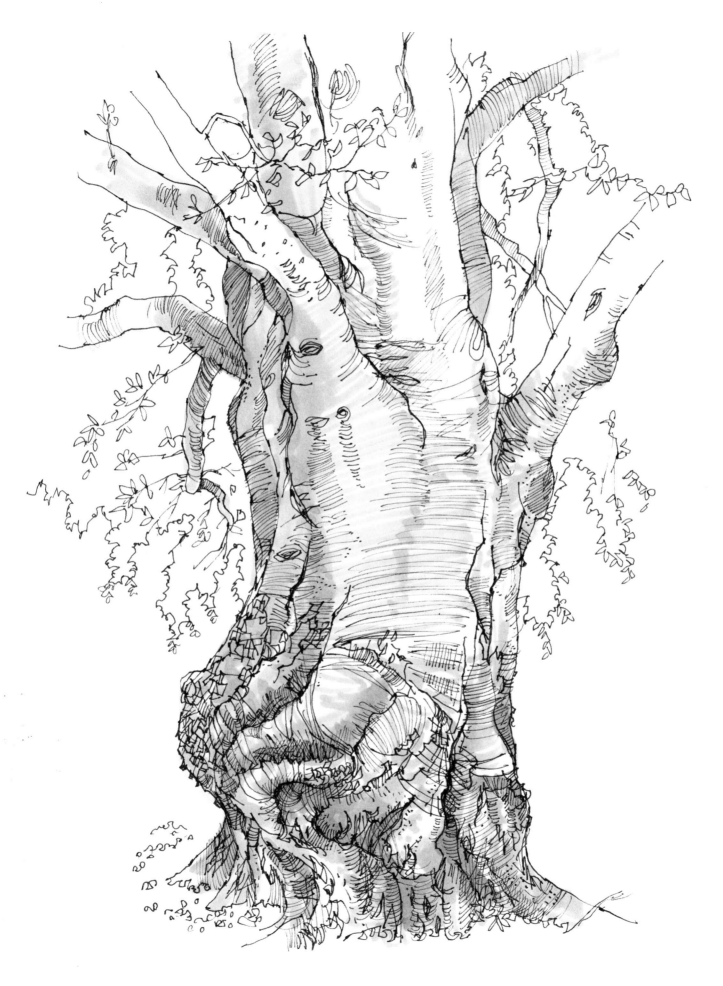

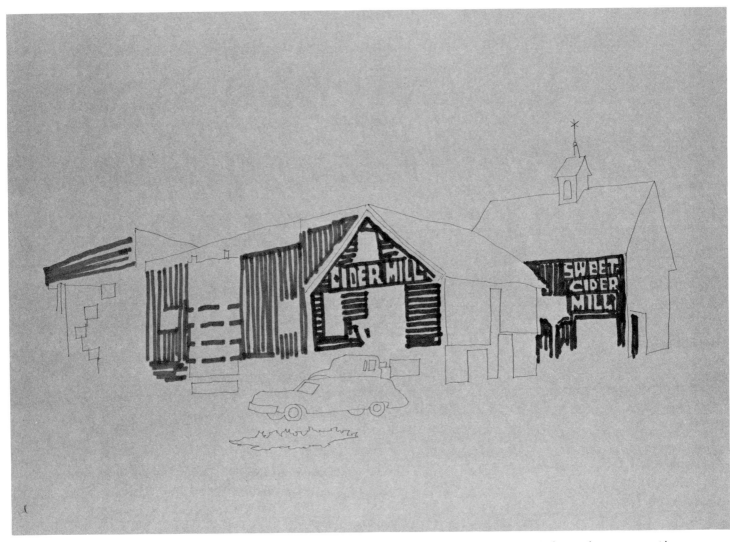

Step 1. First I pencil in some of the major shapes of my subject on a 16" × 22" sheet of gray paper. I keep the pencil lines light so they will erase easily. Using marker grays 6 and 7, I draw in some of the siding, being careful to make the lettering fairly legible.

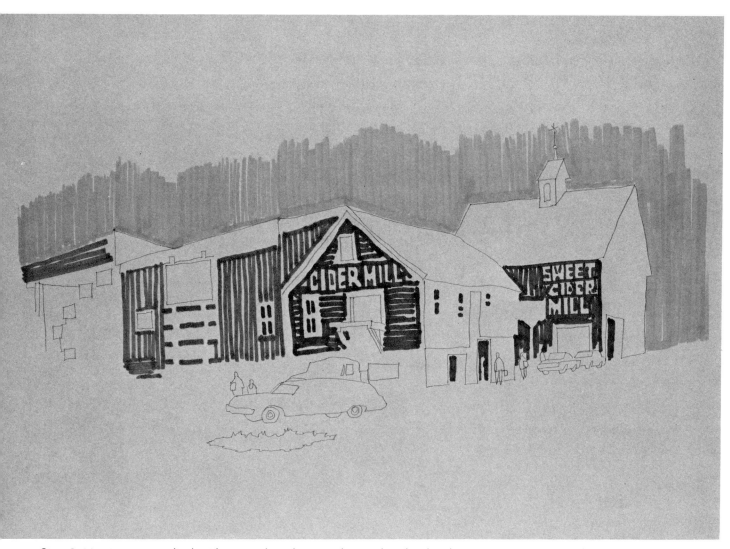

Step 2. No. 3 gray, applied with vertical strokes, works out fine for the sky. Two more cars are drawn in the background—they arrived after I had begun to draw. Keep your mind open to change when working outdoors; your subject might change—as this one did—during the course of your sketch.

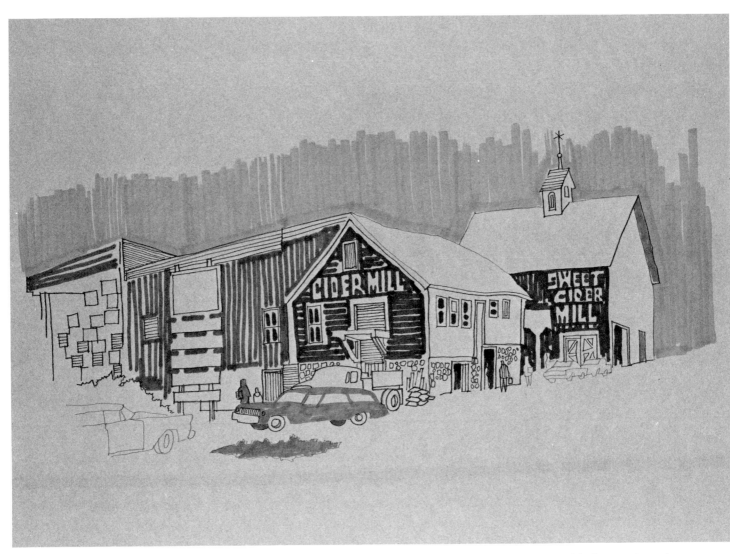

Step 3. In this step, car, figures, windows, doors, and stone texture have been added. Gray lines have been drawn with a No. 4 Illustrator fine-line marker. (This ink smudges easily until dry, so be careful with your lines.)

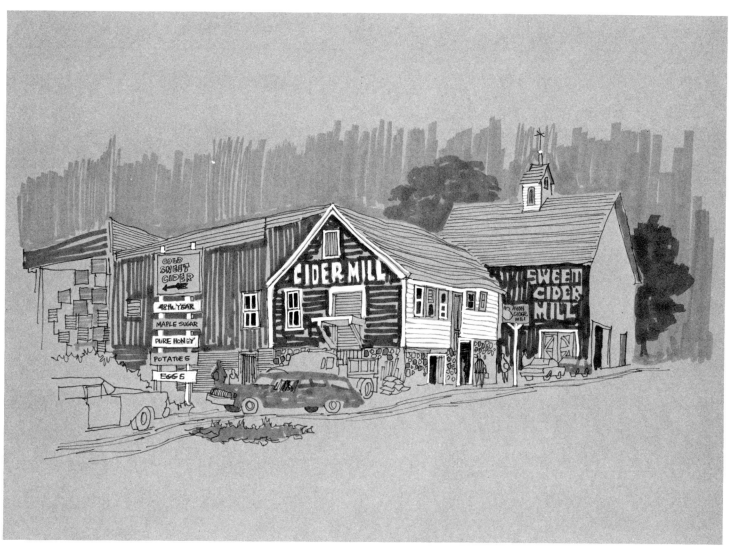

Step 4: Cider Mill. Here's the final drawing. White ink has been applied to signs, lettering, siding, and the distant cupola. Your No. 7 round brush will be fine for this detail work. When I was through with this sketch I went over and bought a gallon of cider. It was delicious!

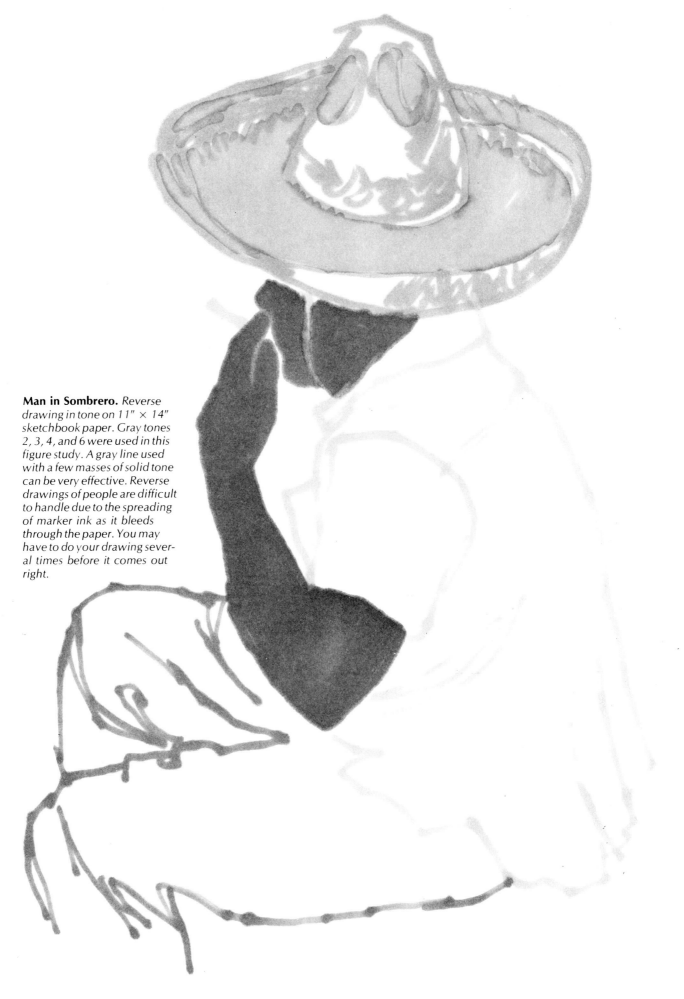

Man in Sombrero. *Reverse drawing in tone on 11" × 14" sketchbook paper. Gray tones 2, 3, 4, and 6 were used in this figure study. A gray line used with a few masses of solid tone can be very effective. Reverse drawings of people are difficult to handle due to the spreading of marker ink as it bleeds through the paper. You may have to do your drawing several times before it comes out right.*

12
FIGURE DRAWING

There's a saying about drawing that if you can handle the human figure well, you can draw anything. I believe this. To be able to draw a figure so it looks good takes a tremendous amount of perception and skill by the artist.

In the beginning, a lot of artists will spend a good amount of time drawing the human body to develop their drawing skill. This will prompt them to try other subjects. What I have in mind is the exact opposite. Draw a multitude of subjects—trees, houses, old cars, flowers, bottles, etc. to sharpen your eyes to proportion, form, and texture, and then when you have mastered these fairly well, try some figure studies.

Sooner or later you'll want to try your hand at drawing a person, a face or a crowd of people. Your first attempts might be way off in proportion, but stick with it. You'll probably make an arm too long or the head too big, but these are common errors and with each succeeding figure study you complete, these things will begin to take care of themselves because you'll be seeing better and drawing better.

START WITH THE SEATED FIGURE

Ask a friend to pose for you. Have him (or her) relax in a comfortable chair. Try a side view first from about six to eight feet away. It's not a bad idea to start with the head and work down. Work in a sketchpad of at least 14″ × 17″ and lightly sketch in the figure with a soft pencil. Then go over it with a fine-line marker, using a contour technique. Keep your first sketches simple. Don't go for a likeness in the face or become involved in intricate shading. This can come later. Right now you want to concentrate on proportions, the key to good figure studies.

Spend about 15 to 20 minutes on each drawing and when you have completed two or three, spread them out in front of you and look at them for correct proportions. Head too small? Arms too long? Hands too big? Feet too small? Try some more studies with corrections in mind. Don't get discouraged! Figure drawing is tough and if you put your mind to it, you can turn out some credible sketches.

DRAWING THE NUDE

The nude is the ultimate in figure drawing. Unlike the clothed figure, where you have a blouse or pants or fancy folds to help you cover up any mistakes you might make in proportions, the nude must stand on superb draftsmanship only.

The best way to get involved with nude studies is to enroll in a life drawing class at a local museum or art school. If neither of these is available, contact an artist in your vicinity and see if he has a class for beginners.

This will give you the advantage of professional help and a good cross-section of models.

DRAWING FACES

Almost as difficult as the nude is the human face. The key here is proportion.

Begin with the forehead and work your way down to the nose, lips, chin, and neckline. Go back to the top of the head and put in as much hair as you feel necessary. Keep your drawing simple and try to get as good a resemblance as possible. You may have to draw that profile a dozen times before you get it right.

Here's a little tip about drawing profiles: if you're right-handed, draw your subject's face looking to your left; if you're left-handed, draw the face looking to your right. You'll find your hand movements easier when the head is drawn in this position.

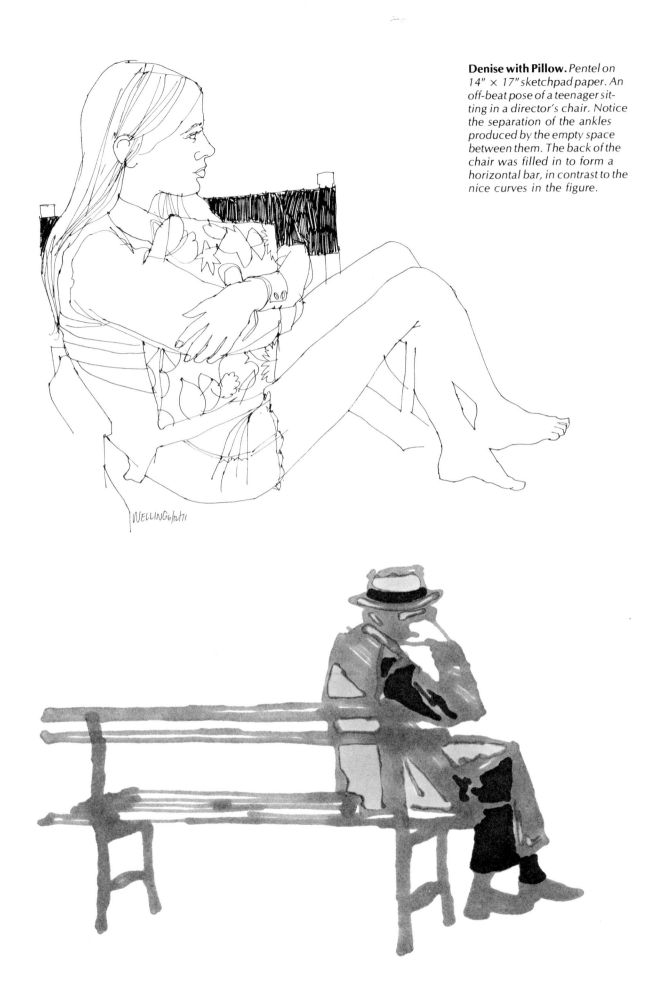

Park Bench. *(Left) Reverse drawing on 11″ × 14″ sketchbook paper. Drawn with marker grays 2, 4, and 8. This is a poster technique in which you go after big areas of tone rather than picky details. Once again, subtlety is the key word here. Tell as much as possible with as little as possible. Dark accents were kept to a minimum and placed where they would do the most good.*

Scientist. *(Above) Pentel on 14″ × 17″ sketchpad paper. This gadget has something to do with air pollution. The glassware was drawn first to be sure I would get it all in and the figure was added at the end of my sketch. It's safer to work the other way around: draw the figure first, then put in the surrounding equipment. If the figure you've drawn looks good, the rest of the drawing will fall into place.*

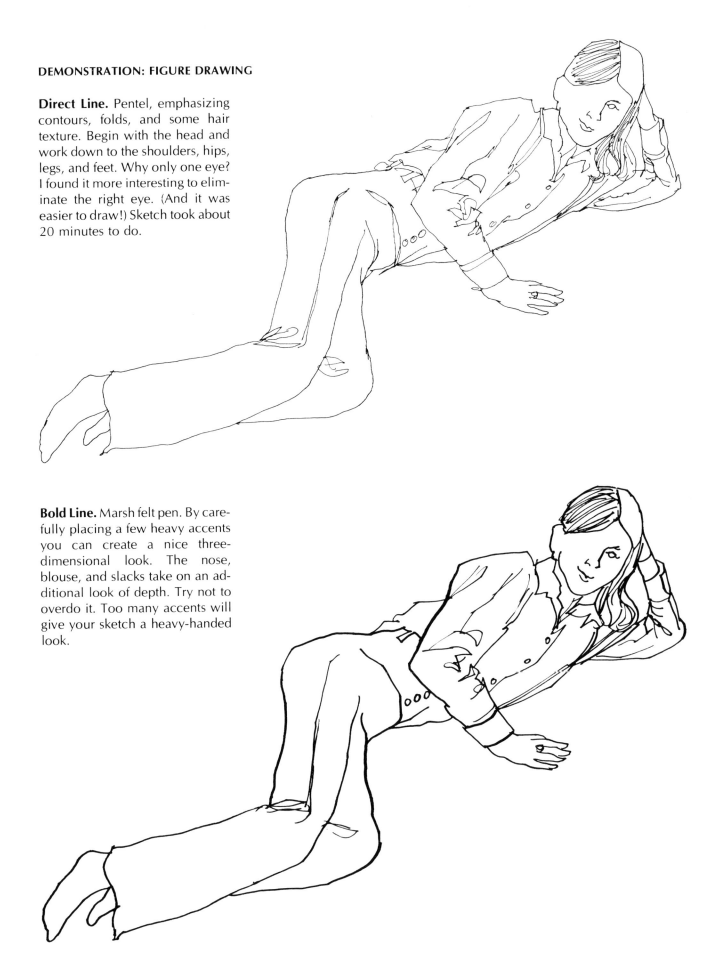

DEMONSTRATION: FIGURE DRAWING

Direct Line. Pentel, emphasizing contours, folds, and some hair texture. Begin with the head and work down to the shoulders, hips, legs, and feet. Why only one eye? I found it more interesting to eliminate the right eye. (And it was easier to draw!) Sketch took about 20 minutes to do.

Bold Line. Marsh felt pen. By carefully placing a few heavy accents you can create a nice three-dimensional look. The nose, blouse, and slacks take on an additional look of depth. Try not to overdo it. Too many accents will give your sketch a heavy-handed look.

Reverse Line with Gray Tones.
Magic Marker pinstrip marker and gray tones 4 and 6 for the tone areas. The two tones reinforce the reverse line nicely and make the white blouse look all the whiter. Drawn on lightweight bond paper to create a soft line and flat, even tones.

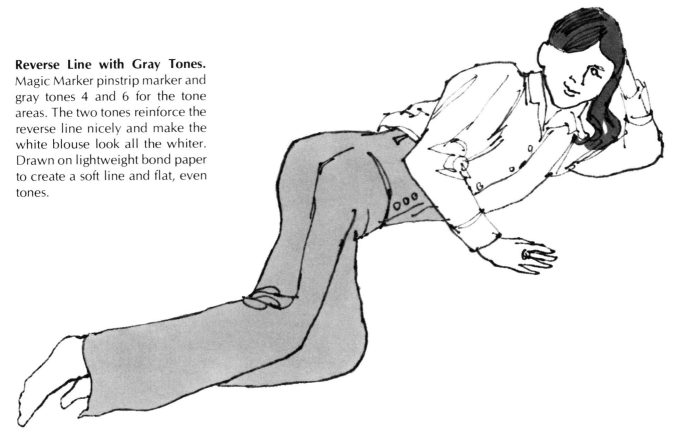

Nervous Line on Gray Paper. Pentel on light gray pastel paper. Notice the volume created in the slacks by having some of the shading follow the contour of the material, which, by the way, didn't look anything like my sketch. I created the pattern as I went along.

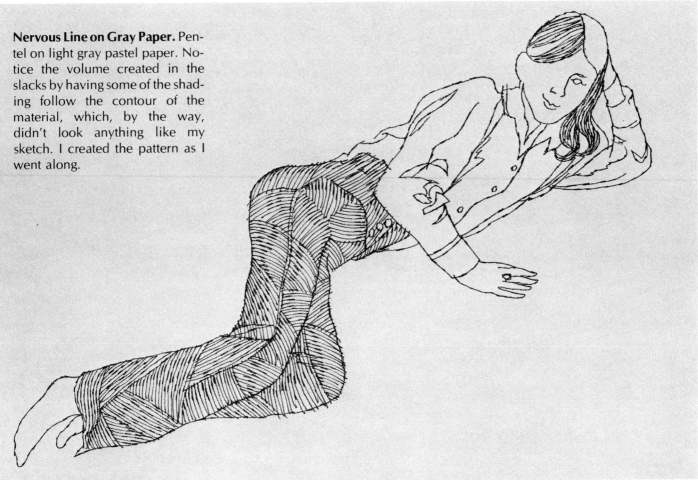

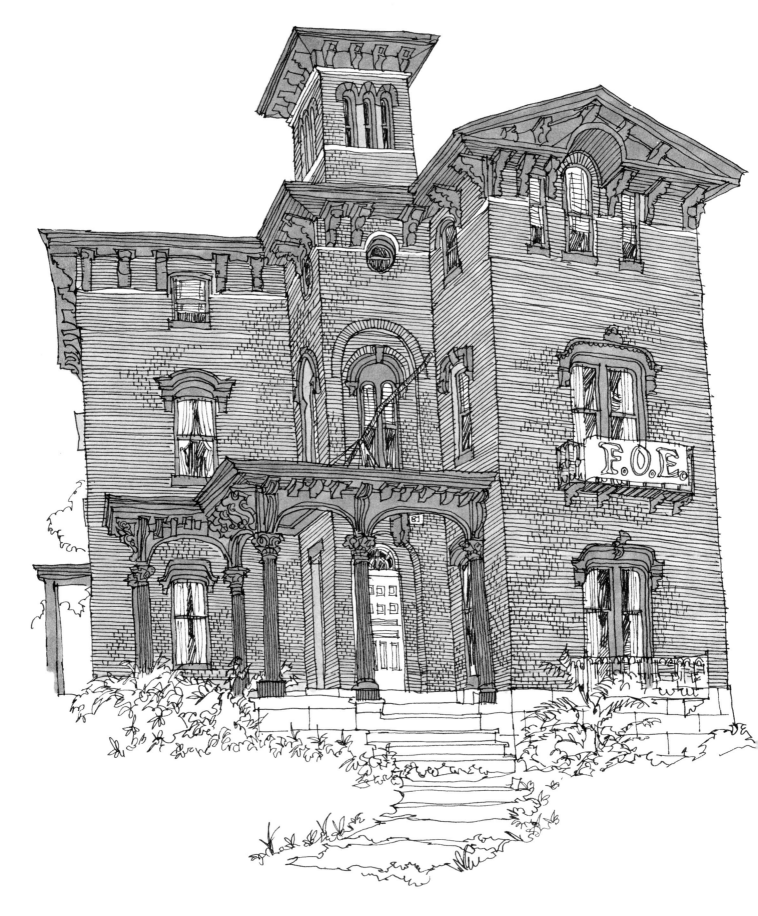

Old House, Hartford. *Pentel line and marker grays 3 and 5 on 15" × 20" sketchpad paper. A wonderful subject, worthy of anyone's sketchpad! The two grays add substance to the line framework. The flat, even look of the tones was accomplished by filling in a small section at a time with a fresh, moist marker.*

13
ARCHITECTURE

Architectural subjects are my favorites. There's something about a cluster of skyscrapers or a narrow side street lined with quaint storefronts that makes me want to draw. The material you can find downtown will fill dozens of sketchpads.

THAT UGLY WORD, PERSPECTIVE

Take my word for it, you can draw some fine city scenes without knowing a thing about perspective! You can, but it requires a good amount of concentration and understanding of what you're looking at. There are two key words: *proportion* and *angles*. Proportion means the shapes of your buildings: square, horizontal, curved, or vertical. Angle means the illusion that the tops of the buildings seem to slant as you look up at them.

This is an oversimplification, but I guarantee that if you get your proportions and angles right, your sketch will have the feeling of depth—which is what perspective is all about.

BEGIN WITH A SMALL BUILDING

Find a small building or house that interests you and draw it. Your viewfinder will help you with composition and scale (how big to make your drawing so it will fit your page). Sketch the basic shapes lightly in pencil and go over them in Pentel. Pay attention to details. If there are bricks, make them look like bricks. Draw the windows carefully and put in the right number of panes. Draw the roofline as accurately as you can and if there are shingles, put them in. Create a pattern with the texture, keeping it active near the entrance and trailing off on either side. Draw several small structures before you go on to bigger things.

DRAWING DOWNTOWN

You must have confidence in your ability before you venture into the city to draw. Cities are full of color,

movement, life, and sound; they can be pretty overwhelming to the artist. Your best bet is to begin by going downtown on a Sunday. No one is around and traffic is light.

Draw one side of a street. Try to get your proportions and angles correct. Once you do, windows, trim, and texture will all fall into place. Keep your shading simple. If you're using grays, one or two tones will be enough to begin with.

Try a skyscraper. Begin at the top and work down. Counting the floors will help you judge its height and will help you space the windows. If it's a really tall structure, position your paper vertically. Don't stand too close to the base of the building; if you do, the distortion will be extreme and you might lose the character of the architecture.

OTHER CITY SUBJECTS

Besides street scenes and skyscrapers you might like to try your hand at a bridge, or a transportation subject such as an airport.

Bridges are big, bold, and exciting. Find a good vantage point and begin. You don't have to include the whole bridge; the roadway and one tower are sufficient to tell your story. If it's a stone bridge, draw your stones so they look equal to the task imposed upon them.

WHEN TO ADLIB

The ability to adlib visually is an asset. Every now and then you'll find a dull area in a composition. For example, it could be the side of a building without windows located in a prominent spot of your sketch. This large, flat area could be an eyesore. Adlib some windows if possible. If that doesn't work, draw in a large billboard. But whatever you adlib, make sure it works for that particular sketch.

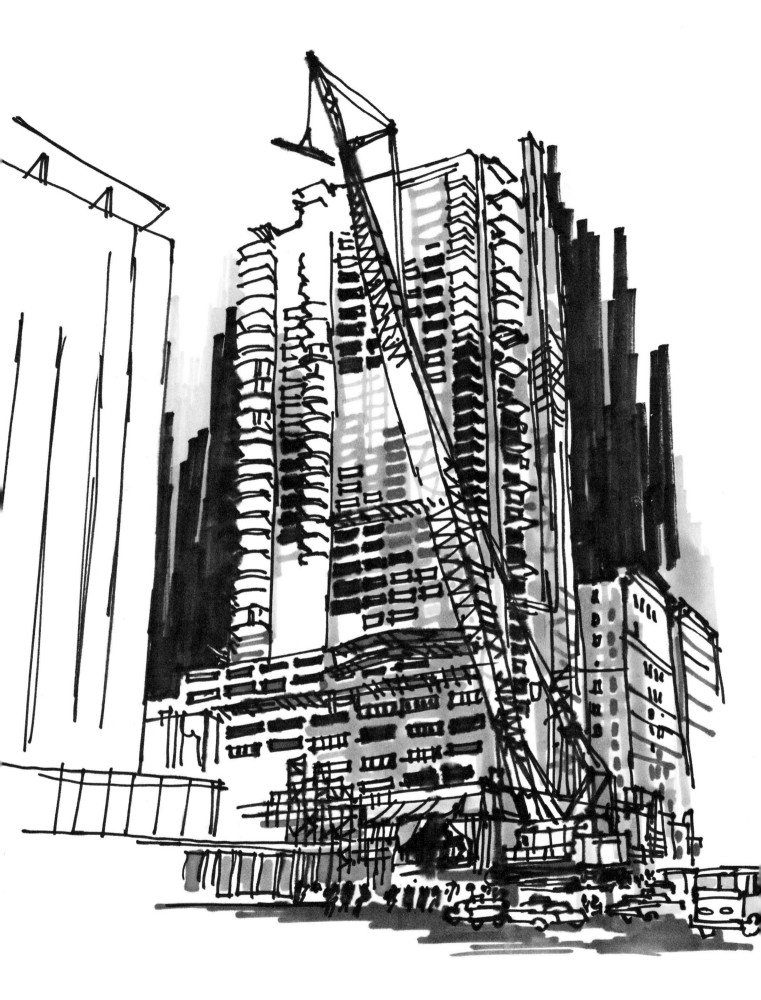

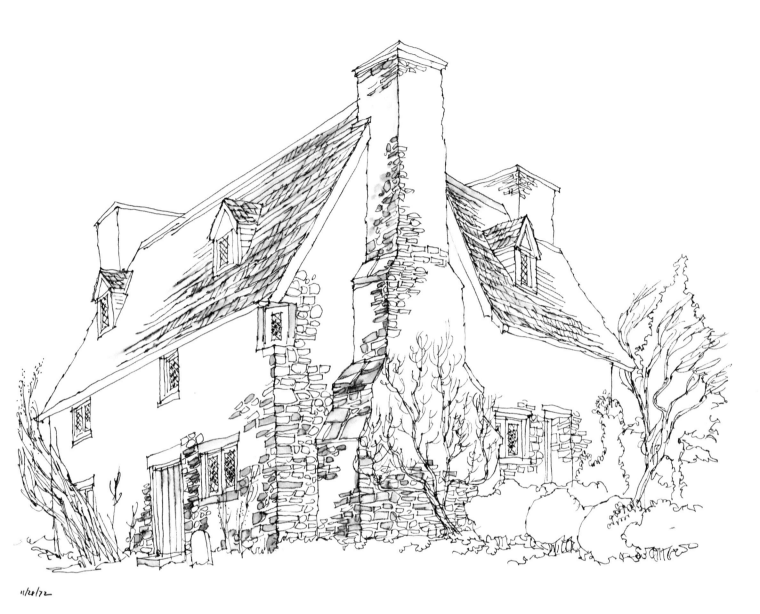

11/28/72

West Side Construction. *(Left) Reverse drawing with warm marker grays 3 through 9 on 15″ × 20″ sketchpad paper. A line drawing was made first. This was then traced in the reverse technique described in Chapter 6. A free hand has been used in the placing of the gray tones to add drama to the scene.*

Stone House, Guilford. *(Above) Pentel with wash on 14″ × 17″ sketchpad paper. A simple, restrained use of tone on the roof and on the stones enhances the textural quality of this drawing. Architectural sketches do not have to be bold to be expressive. Drawing completed in about 45 minutes.*

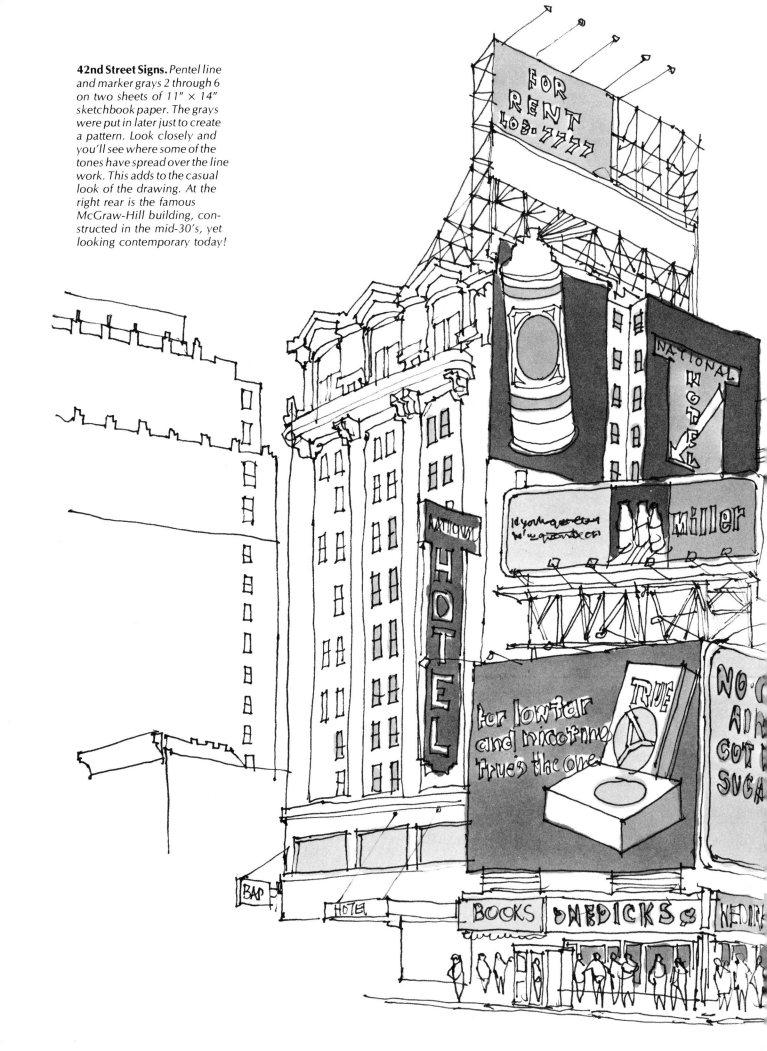

42nd Street Signs. *Pentel line and marker grays 2 through 6 on two sheets of 11" × 14" sketchbook paper. The grays were put in later just to create a pattern. Look closely and you'll see where some of the tones have spread over the line work. This adds to the casual look of the drawing. At the right rear is the famous McGraw-Hill building, constructed in the mid-30's, yet looking contemporary today!*

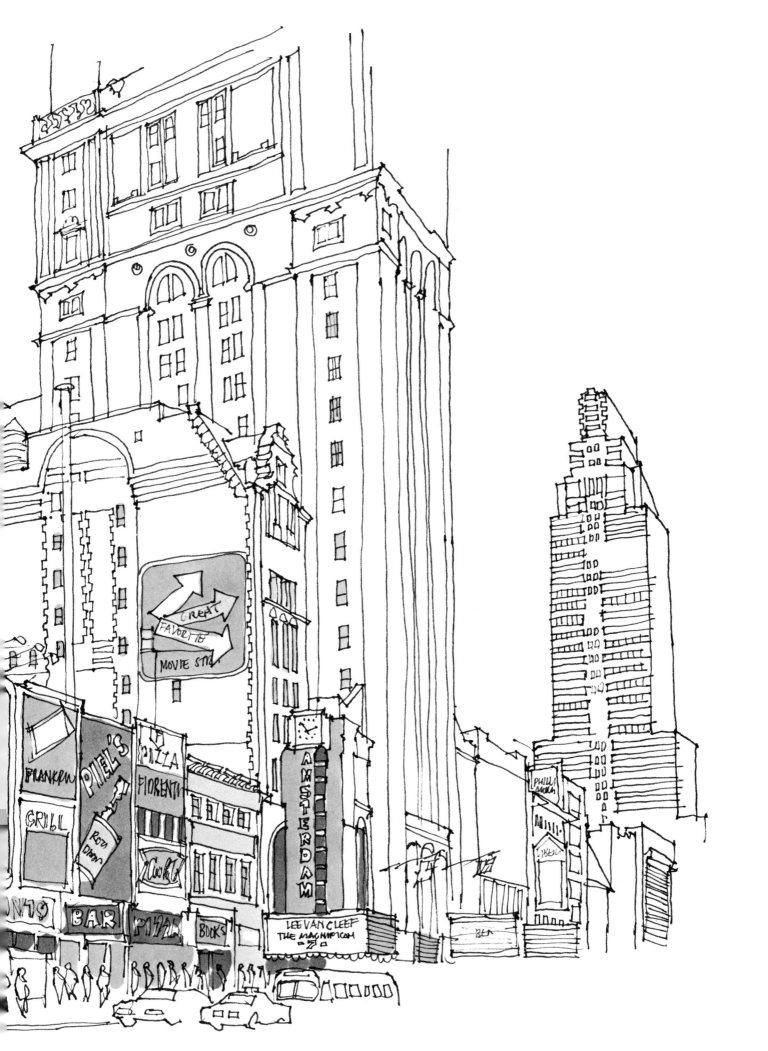

Step 1. Pentel on a sheet of 15″ × 20″ sketchpad paper. Churches are good subjects; scout some out in your neighborhood. I started with some of the foliage cutting off the top of my subject. With any architectural subject, work your way down through it a section at a time, as I've done here.

Step. 2 The front has been firmly established, along with the side of the building facing away from the viewer. For a good three-dimensional effect, get the slant of the roofline correct. I've followed some of the trim lines around the sides to aid me in positioning other elements correctly.

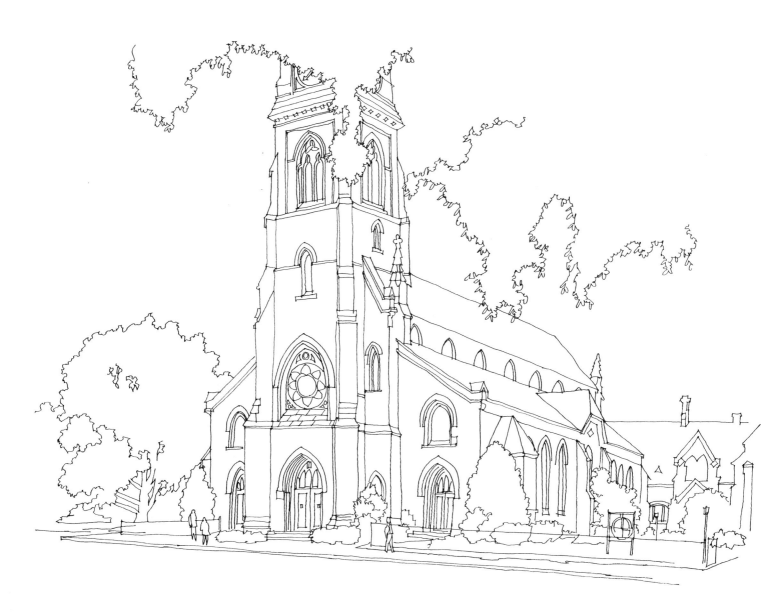

Step 3. When your sketch reaches this stage, you can begin to relax a bit. The windows and some details have been started; a few figures in the foreground emphasize the size of the structure.

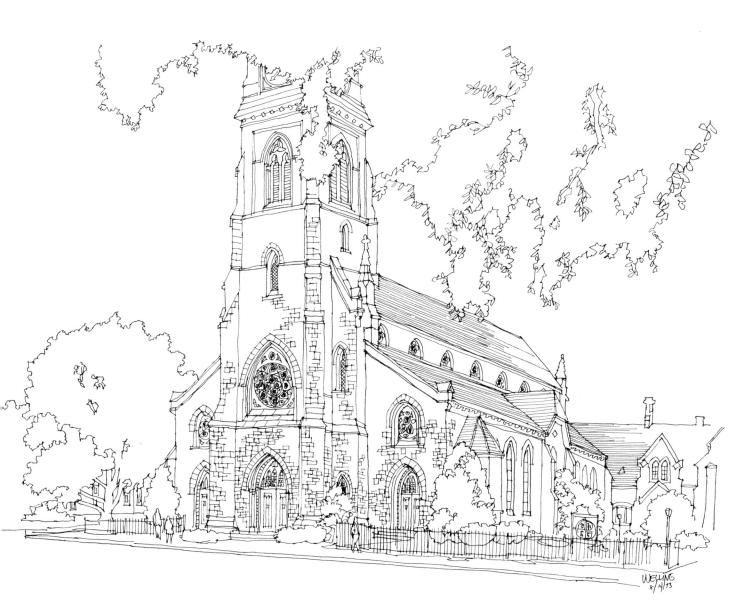

Step 4: Asylum Hill Church. This is the finished line study. Stone and roof texture add a feeling of solidity to the building. All the foliage has been kept simple but interesting. Drawing took about 2 hours to complete.

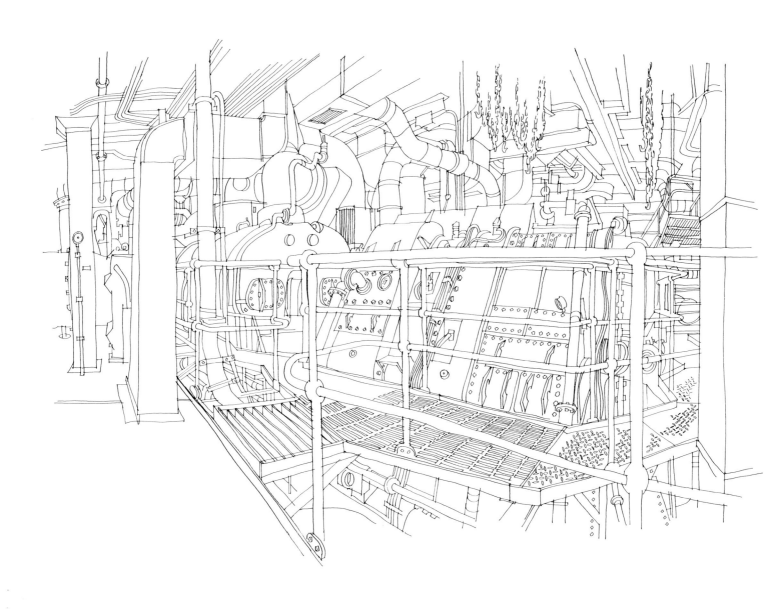

Engine Room, QE 2. *Pentel on 18" × 24" sketchpad paper. An exciting subject for any mechanically minded artist! This sketch was started with the railing in the foreground, which helped me keep my place as I drew the machinery behind it. Even though my perspective is off in several places you still get a convincing feeling that this massive engine will run.*

14
MANMADE OBJECTS

As a youngster, I developed a love affair with the steam locomotive. My affection for this mechanical monster continues even today and that's why I've included several drawings of engines in this book.

Locomotives, airplanes, motorcycles—and even typewriters—are wonderful subjects for your sketchpad. Don't overlook them because of their size or complexity. Steady concentration and the ability to draw what you see will make you a winner!

SMALL OBJECTS

Think small (as a popular brand of foreign car says in its ads) in your first attempt at drawing manmade objects. Try your hand at a telephone or a camera. Watch out for the telephone dial and the camera lens, which being round will appear as ellipses. How fat or thin the ellipses will be depends on your position as you look at circular forms. Draw the form just as you see it. Most people have a tendency to make their ellipses fatter than they appear, so watch out for this common error.

Study the basic shapes of your object and the angles made by the top and bottom edges. If you draw a typewriter, and want extreme accuracy, count the keys in each row and draw in the letters.

MEDIUM-SIZED OBJECTS

In this category I include bicycles, motorcycles, furniture, and automobiles.

Cars are a real challenge. You've seen hundreds in your lifetime, but when you try to draw one, ugh! A Volkswagen is a nice beginning: it's small, with easily comprehensible surface curves. Draw a direct side view from a sitting position and try for a feeling of depth by showing the far side of the car as seen through the windows. Begin your sketch with the roofline and move down to the windshield, hood, fenders, and wheels. Take it piece by piece so that everything will fit together.

Motorcycles are splendid, with their intricate

engines, chain drive, and spoked wheels. Begin with the seat, which is a large shape. Build the rest of the bike around it and watch your proportions. A motorcycle is an elegant machine; don't draw it with bloated parts. Check the pattern of spokes carefully to add to the realism of your drawing.

VERY LARGE OBJECTS

I believe that if you can see something, you can draw it—no matter how large it is. The secret here is to set the right scale so you can fit the object on your paper. This takes practice; in your first attempt at drawing an airplane you might wind up with parts of the plane running off your sketchpad. To have parts of a large object go off your page can sometimes be to your advantage—it will make your subject look that much larger. But if the area that you can't fit in is critical, you may become discouraged. So practice setting the right scale in your mind's eye before you start to draw. Your viewfinder can be of great help here, too.

POSITIONING IS IMPORTANT

Locating your subject on your sketchpad is almost as important as setting the right scale. Balance your pad on one hand and with the other block in some of the major shapes with your finger. This helps clue your eyes in to the areas involved and gives you a rough idea as to whether or not you can fit everything in. If you see you're off, try blocking in the areas on a different spot on your paper.

GET A CLOSE LOOK

If you're sketching something mechanical and you can't figure out some of the details, go up to it if possible and take a closer look. Try to draw accurately at first. After you've done a few manmade objects you might want to adlib details on your own for added interest. If you do, make them look plausible.

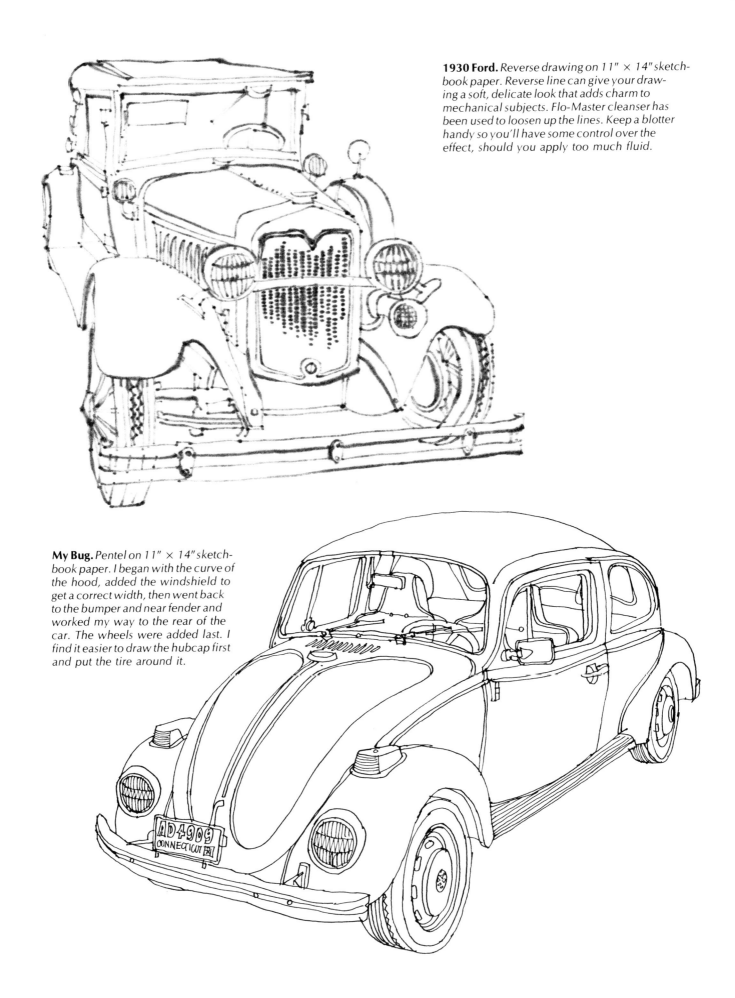

1930 Ford. *Reverse drawing on 11" × 14" sketch-book paper. Reverse line can give your drawing a soft, delicate look that adds charm to mechanical subjects. Flo-Master cleanser has been used to loosen up the lines. Keep a blotter handy so you'll have some control over the effect, should you apply too much fluid.*

My Bug. *Pentel on 11" × 14" sketch-book paper. I began with the curve of the hood, added the windshield to get a correct width, then went back to the bumper and near fender and worked my way to the rear of the car. The wheels were added last. I find it easier to draw the hubcap first and put the tire around it.*

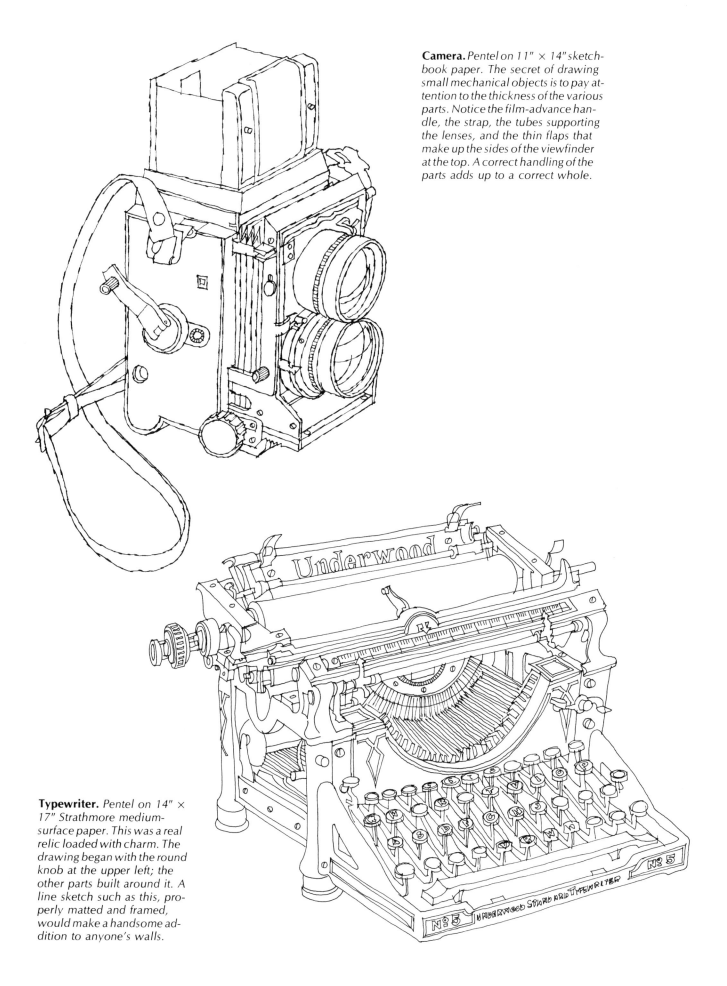

Camera. *Pentel on 11" × 14" sketchbook paper. The secret of drawing small mechanical objects is to pay attention to the thickness of the various parts. Notice the film-advance handle, the strap, the tubes supporting the lenses, and the thin flaps that make up the sides of the viewfinder at the top. A correct handling of the parts adds up to a correct whole.*

Typewriter. *Pentel on 14" × 17" Strathmore medium-surface paper. This was a real relic loaded with charm. The drawing began with the round knob at the upper left; the other parts built around it. A line sketch such as this, properly matted and framed, would make a handsome addition to anyone's walls.*

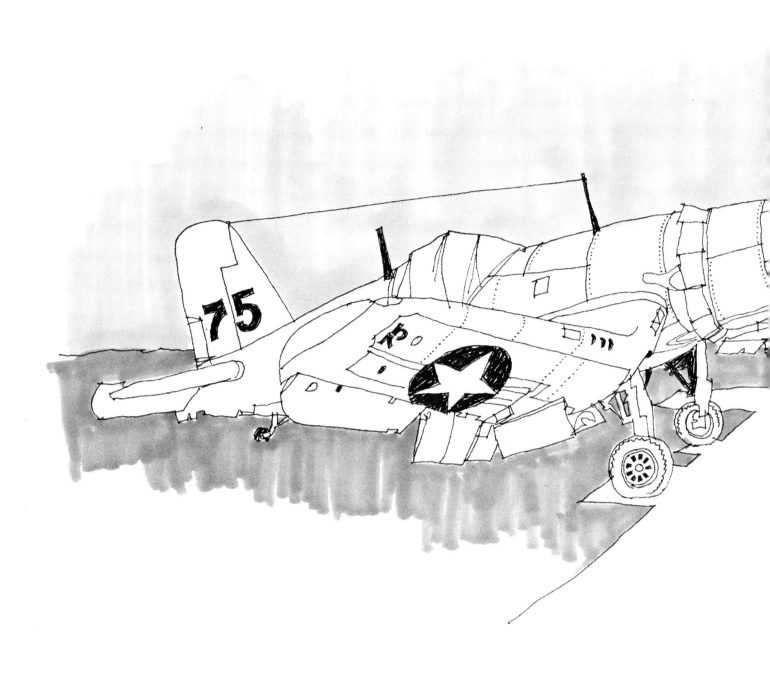

Retired Veterans. *Pentel and markers on slightly textured 14" × 18" paper. Number 75 is a good example of drawing something just as you see it, not as you think it should be drawn. That projecting wing had to be drawn just as it looked from my viewpoint, otherwise it wouldn't have joined the fuselage correctly. Learn to depend on your eyes!*

Bulldozer. *(Below) Markers on 11" × 14" sketchbook paper. The outline was drawn with a No. 5 gray and various tones were used to fill in the areas. Quite a bit of paper was left white to give the effect of sunlight on the machine. This technique works for almost any mechanical object.*

Step 1. After selecting a good composition, I begin with the nearest car and start drawing some of the major shapes with a Pentel pen on 15" × 20" sketchpad paper: body, fenders, windshield, and hood. The spare tire has also been positioned on the side of the car.

Step 2. Continuing back, I add parts of three more vehicles. When drawing in nervous line, be sure to maintain a constant pressure (very light!) with your felt pen so the weight of your line doesn't vary.

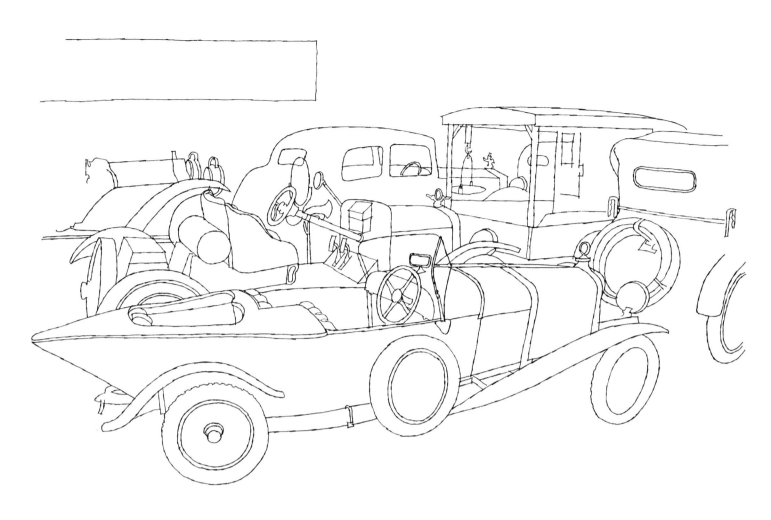

Step 3. You get a good idea of this dandy cluster of old cars in this step. Wheels are difficult to draw, so I usually save them until last. I was standing so close to the nearest car it seems to be twisting away from you as you look at my drawing. This is one of the optical hazards you are faced with when drawing in confined quarters.

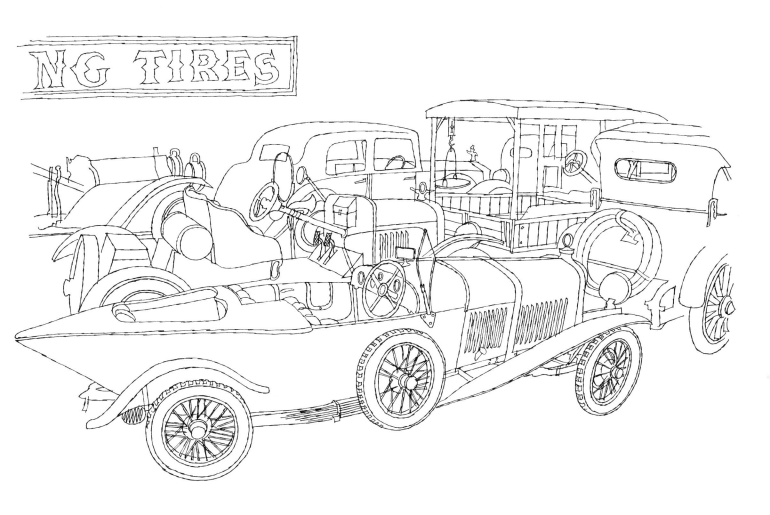

Step 4: Antique Autos. Rims, spokes, hood slots, and finishing details have been added to wind up the drawing. You will find it easier if you pencil in your subject first. I don't do it any more because drawing directly in ink is much more satisfying.

Victorian Room. *Pentel on 16" × 22" gray paper. Black line on gray paper is a handsome combination. The ornate chandelier was my starting point for this intricate interior of a room in the Wadsworth Atheneum, Hartford, and I had to draw it twice! (See the reflection in the mirror on the right!)*

INTERIORS

Interiors are splendid subjects when the weather doesn't allow outside drawing. A corner of a room showing intersecting walls, a few pieces of furniture, and perhaps a window will create a nice composition for your sketchpad.

WHERE TO BEGIN

After settling on a composition (your viewfinder can help you inside as well as outside) and with a drawing style in mind—direct line is a good one to begin with—start drawing one of the large shapes in your scene. This will set the scale for everything else in the room. All pieces of furniture are related to each other depending on where you're sitting. You'll see more of the top of a table close to you than one further away. Observe the subtle relationships with a critical eye and your work will be the better for it.

PROPORTION IS IMPORTANT

The furniture in your sketch should be drawn with a fair amount of accuracy. Be watchful for the length and thickness of legs on chairs and tables. If something looks square to you, draw it square. If a couch looks long and narrow, draw it long and narrow. Try to get into the habit of drawing objects just as they look to you from your position, *not* as you think they should look. Depend on your eyes, they are the best piece of art equipment you've got!

NEGATIVE SPACE

The space between objects is often called "negative space." An understanding of this term will help you draw anything. Let me give you a few examples, because we are surrounded by negative space. The space between the legs of a chair, the space between two buildings, the empty triangle formed when a person puts his hand on his hip, the empty space between girders of a bridge. Begin to get the idea?

By paying attention to the negative areas in your subject as you draw the solid parts, your drawing skill will improve. It may sound strange, but it's a fact!

LARGE AND SMALL ROOMS

Large rooms can best be captured by starting with the walls and ceiling and working your way into the room. In this way you have established the volume first. Small rooms can best be drawn by beginning with a piece of furniture and building the room around it.

LOCATION DRAWING

Should you desire to draw the interior of a museum or historic spot, get permission first. Then try to pick a good composition that puts you out of the way of traffic. The bound sketchbook is good to work in and a simple contour line technique will let you capture details and atmosphere. Make a few margin notes relating to color and tone values in your drawing so you can add them later if you want.

DETAILS

The amount of detail you put into your room interior depends on the mood and feeling of your sketch. A Victorian room can stand detail all over, while something contemporary might require very little.

Fancy mouldings and trim can be simplified as you draw them. Don't scribble! Try to use an organized, free-flowing line that still tells the message. Your own visual shorthand can come in handy here.

Drawing the "inside story" can be fun—enjoy it!

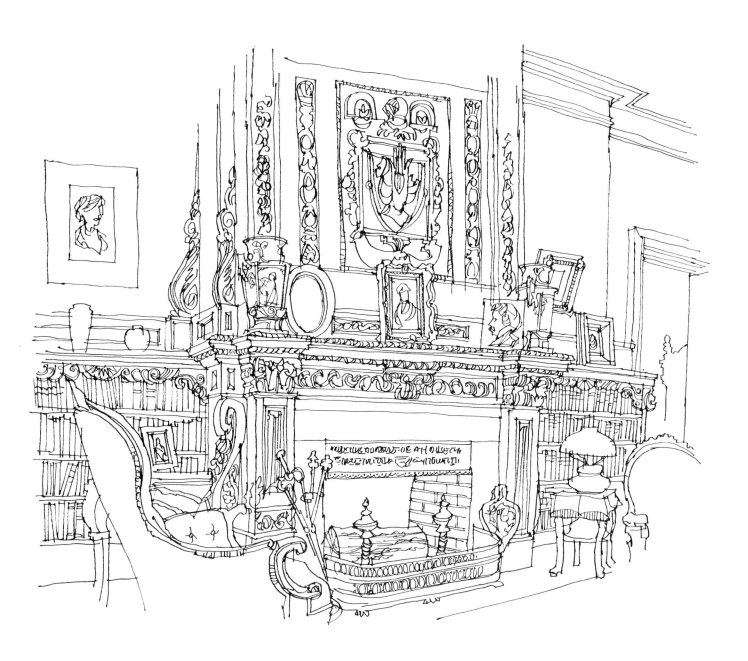

City Hall, Hartford. *(Left) Pentel on 15" × 20" sketchpad paper. With a large room, begin with the walls or with some prominent feature of the architecture. I began this drawing with the square column in the center and worked my sketch to the right and left of it. What you see is the result of 90 minutes' effort.*

Mark Twain's Library. *(Above) Pentel on 14" × 17" sketch-pad paper. A loose but fairly accurate direct-line technique was ideal for this subject. When drawing a section of a room, pick a prominent feature as your starting point. In this sketch, I began with the mantle and worked above and below it. Details were greatly simplified, yet still remain interesting.*

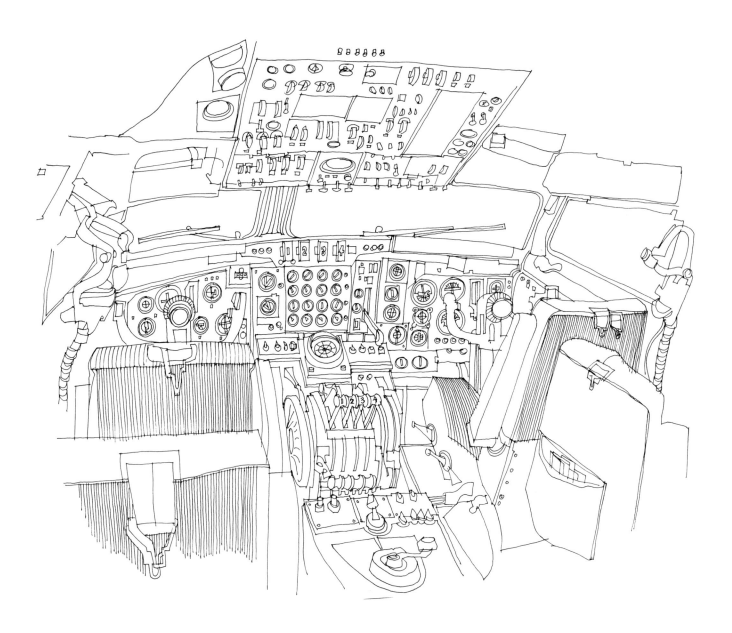

Flight Deck. *Pentel on 14" × 17" Strathmore medium-surface paper. Talk about an interesting subject, wow! The sketch commenced with the two windshields. I won't vouch for the correctness of this drawing, but it sure looks as though you could take off using those instruments!*

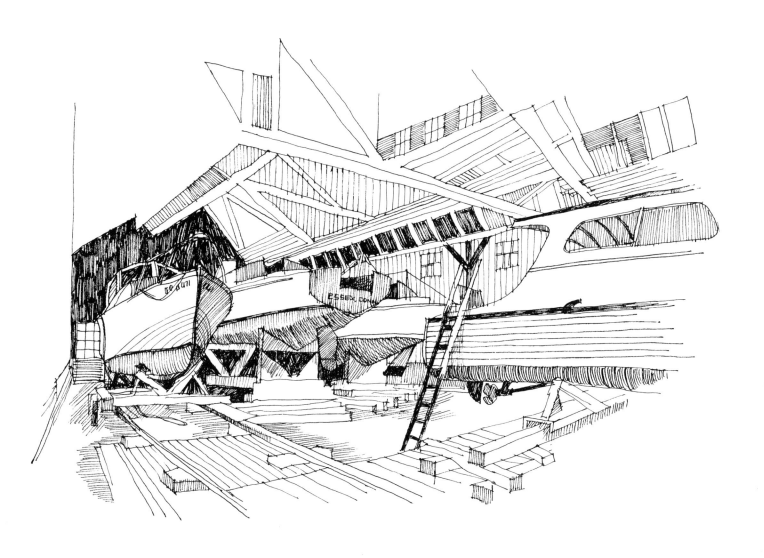

Boatyard, Essex. *Pentel on 14" × 17" sketchpad paper. I began the sketch with the boat at the left and progressed across the page to the right. Simple line-shading heightens the abstract feeling of this interior.*

Step 1. I begin my drawing of the staircase of this beautiful Victorian house at the bottom of my 14″ × 17″ sketchpad paper to give me room to work up into my composition. My line is very loose, to capture the flavor of the subject.

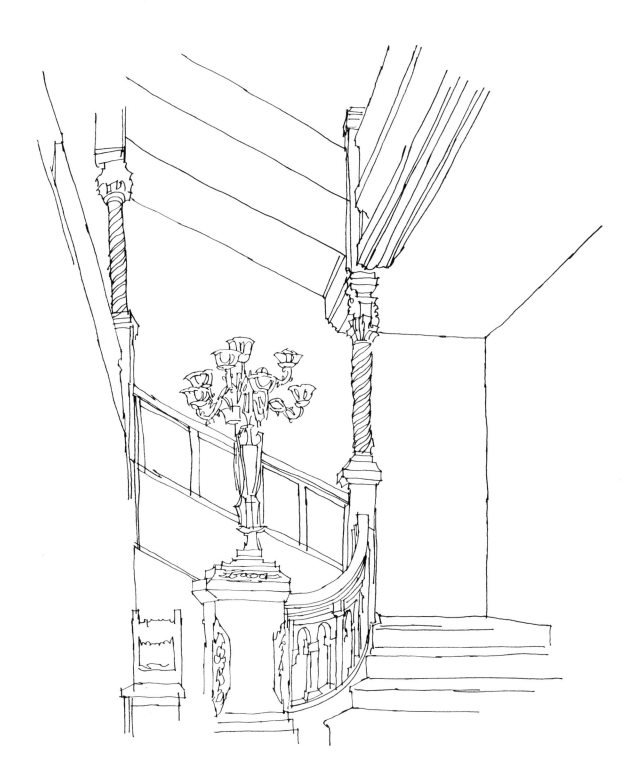

Step 2. In any interior, try to get the proportions correct and on a human scale. As you look at this drawing you get the feeling that a person could actually walk up these stairs because there is enough room. Spend some time studying your view before you put down a line.

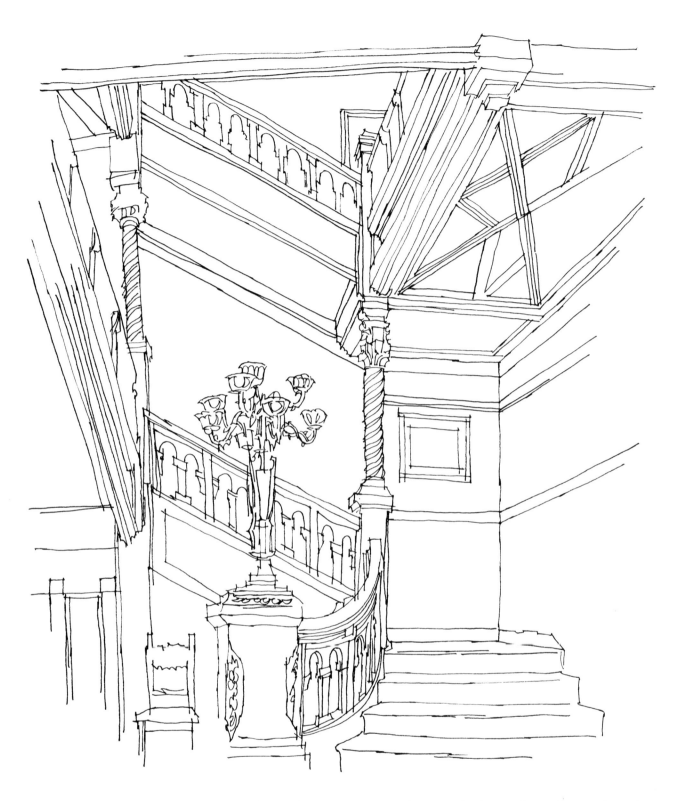

Step 3. A real solid look is evident in this step. A correct downwards slant to the ceiling on the right is the key here. Notice how it leads your eye past the spiral-turned column to meet the far wall. Some details have been started.

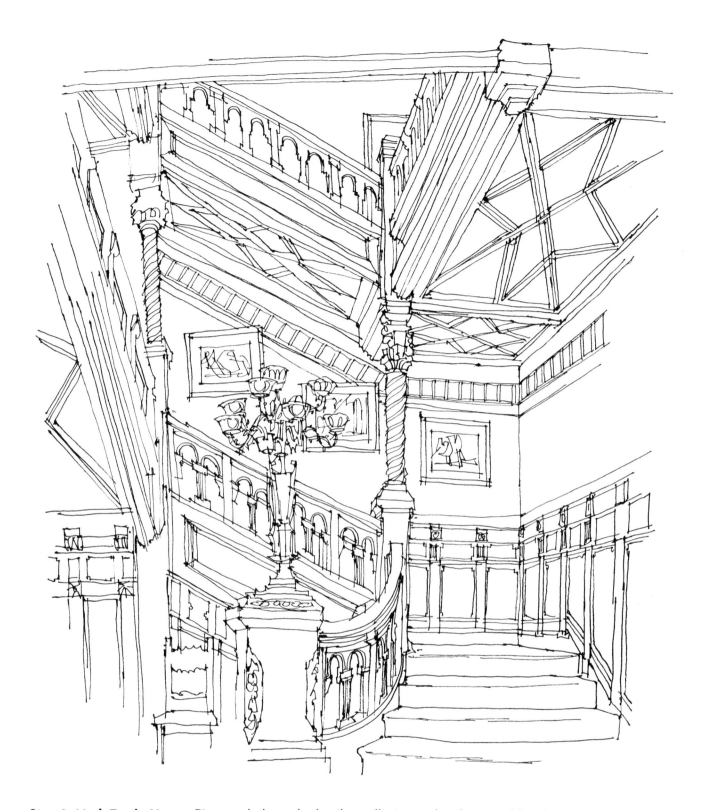

Step 4: Mark Twain House. Pictures, balustrade details, wall trim, and ceiling moulding have been added to complete the sketch. I eliminated the wallpaper pattern for the sake of clarity. A view of the library in this house, drawn on the same day, can be seen on page 145.

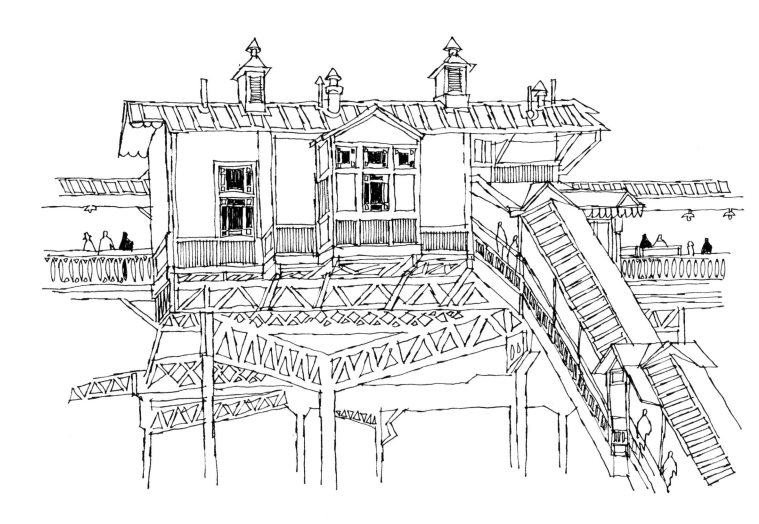

EL Station, Manhattan. *Pentel on 11" × 14" sketchbook paper. When drawing in nervous line, try for patterns rather than realism, and your drawings will take on a nice design quality. Save your city sketches (this one is over 20 years old); they may become collector's items someday.*

16
DRAWING ON LOCATION

Drawing on location is always an exciting adventure for the artist. Here's where you put everything on the line in anticipation of creating some good sketches—and the rewards are many. Your drawing skill will improve with your location drawing, and you'll want to try different techniques to capture the wide range of subject matter that you'll be surrounded with.

If you're working on a landscape, for example, you can't help but marvel at nature's hand: the play of light and shadow on leaves is lovely to behold; a gnarled old weatherbeaten tree, staunchly braving the elements is a subject worthy of anyone's sketchpad.

Let your eyes roam far and wide to soak up the patterns and colors in front of you before you put down a single line or color. Your work will be the better for it.

USE YOUR OTHER SENSES, TOO

Let your other senses help you tune in on your subject. Before you start drawing that tree, go up to it and feel the texture of the bark. Study the shape and pattern of the leaves. Smell the fragrance of all the green things around you.

If you're downtown, listen to the sounds of the city: the policeman's shrill whistle, cars starting and stopping, footsteps and snatches of conversation from pedestrians. Study the reflections in the glass towers. Most important, enjoy what you're seeing!

WHAT TO TAKE ALONG

There are various methods of attack when going out to draw, based on the amount of equipment you want to take along. The simplest method consists of working only in black and white. You'll need your bound sketchbook and a few fine-line markers in black. With a few well-practiced techniques up your sleeve, you can accomplish quite a lot.

The second method involves a little more stuff: the bound sketchbook, a sketchpad at least 14″ × 17″ in size, black fine-line markers, and three warm gray markers in values 3, 5, and 7. This opens up your bag of drawing styles considerably.

The final method consists of taking along your bound sketchbook, sketchpad, fine-line markers in black and in colors, a set of warm gray and color markers, a folding seat, a No. 7 brush for wash effects, and a small bottle of white ink. You might like to add a few sheets of colored paper in tan, blue, and light gray. With these materials under your arm you should feel confident that you can tackle anything man or nature has created!

MENTAL OUTLOOK AND HEALTH ARE IMPORTANT

Drawings are a product of the mind and therefore it's very important to be feeling good if you're to succeed. There's a similiarity between tennis and sketching: both require 100% concentration. If you forget what you're trying to do on the tennis court, you'll lose. The same will happen to you if you're out drawing and your mind is crowded with other thoughts. An outsider's comment can affect your work too.

I was drawing at the foundation level of the World Trade Center in Manhattan and had just sketched in some of the gigantic columns with their braces when an ironworker came over to see what I was up to.

After a few seconds he said, "You have those cross braces in the wrong place." I looked closely at my drawing, then at the columns in front of me, and I discovered that he was right! But his comment had a defeating effect on my spirits and I could feel my interest in the sketch waning. I tried to stay with it for a few more minutes, but I finally gave up and started a new drawing. It took me quite a while to forget his comment and clear my mind.

Physical health is important too. A head cold is about the worst thing you can have while drawing. Your eyes run and focusing is difficult. In short: your work will have a much better chance of being successful if you're in good mental and physical shape.

ON LOCATION IN THE CITY

City subjects are very exciting and rewarding. You have street scenes, skyscrapers, bridges, historic buildings, construction sites—the list is almost endless. The city, any city, is a goldmine of subjects. You just have to get used to looking. And the more you look, the more selective you'll become; you won't draw the first thing that hits your eye. However, if what you see moves you to action then by all means draw it. Don't pass it up hoping for something better around the next corner. If your eyes tell you that you've got a good view, follow their lead!

DRAWING TECHNIQUES

It's important to have several techniques up your sleeve. A good handling of black line is invaluable, especially a contour line with some simple shading. This technique is a good starting point for any subject. It can stand on its own or take the addition of gray tones or color.

Any other techniques at your command can only add to your drawing pleasure when out on location.

THE QUICK SKETCH

Every now and then a subject will present itself that demands a quick handling and a sure eye. The view of Manhattan from the deck of the Staten Island Ferry is such a subject. The buildings change position and size as the boat moves out. At a time like this a good visual shorthand is required.

Draw a street scene in 15 minutes, a tree in 10, and a landscape in 5. Sound impossible? Not really, when you discover you can use your eyes to get to the heart of your subject. The secret is to simplify: put in just enough to tell your story and no more. This takes practice, but you can do it!

A quick sketch can be a thing of beauty, often more interesting than a highly detailed drawing. Work in your sketchbook. This will force you to keep your scale of elements small, so you'll work faster.

TAKE ANOTHER ARTIST ALONG

Drawing can be a pretty lonely occupation. Granted, you can't go out with a committee—someone to tell you what to draw, someone else to pick your technique, and a third person to act as color consultant! It is nice, though, to have someone to talk to now and then as long as you don't get distracted. If that other person is an artist, so much the better.

I took a delightful ten-day drawing trip to Maine with my daughter, Debrah, who is also an artist. There were no big discussions about subject matter. We just drove along U.S. 1 until we discovered a likely subject. Our sketchpads began filling with drawings of old wrecks, lighthouses, boats, harbor scenes, old houses, and weatherbeaten sheds. It was great!

Debrah was working in watercolor and I was using markers and we supplied each other with visual feedback about our subjects. My pace was a little quicker than hers, so I frequently finished two sketches to her one painting.

On another occasion, I visited Newport, Rhode Island, with Hartford (Conn.) photographer William Bradford. Bill had been itching to shoot some of the famous Newport mansions so we planned a one-day trip. Bill took 80 photos while I completed seven drawings in the four hectic hours we spent there. It was an exciting day for us both and I had to work very fast in my bound sketchbook to keep pace with Bill's desire to see as much as possible during our flying visit.

SPECTATORS AND PANHANDLERS

If you're working on location in a city, you're going to become an attraction. Pedestrians looking over your shoulder can be annoying, but you have to get used to it. Most people will just gawk and move on. Now and then someone might venture a comment about a friend of his who's an artist or make some wise comment to impress the crowd. If you should become involved in a conversation, stop drawing. A running conversation while you're trying to concentrate will only result in your making errors in your sketch.

Panhandlers are easy to avoid if you just ignore them. Try not to notice them and by all means don't let your eyes meet. Once that happens you're hooked and he'll come over to ask for a handout. I was once asked for 50 cents in the middle of Brooklyn Bridge! Keep a few quarters in your pocket or purse if you feel in a philanthropic mood.

UNUSUAL LOCATIONS AND DANGERS

Bridges are a handsome city subject. Unfortunately, they're usually located at the river's edge in deserted or undeveloped areas. Don't try this subject in the

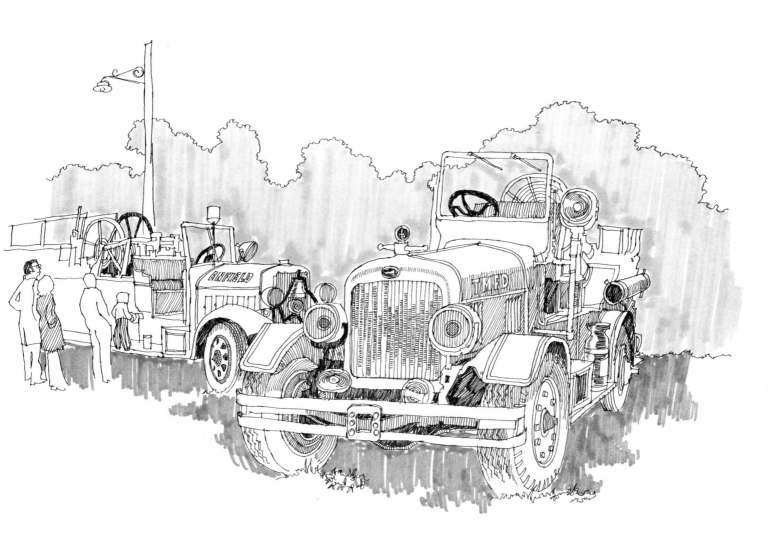

Fire Trucks. *Pentel and Magic Markers on 15" × 20" sketchpad paper. This was drawn on location at an exhibition of antique vehicles. I used colors around the trucks—"putty" for the trees and "sand" for the foreground—to help accentuate them as the center of interest.*

evening by yourself; take a friend along. This is especially true if you're a woman. The safest thing to do is snap a photo for reference and work from that.

If you're working in the country, watch out for poison ivy and other skin-irritating plants. I once found myself sitting in a patch of poison ivy at Yale University while drawing Harkness Tower. I'm not allergic any more, but for a few seconds I could feel my flesh crawl at the thought of it.

WEATHER CONDITIONS

There are three bad weather conditions: cold, rain, and wind. I have already talked about cold in the chapter on landscapes, so let's look at the other two.

Rain is tough. Markers won't take to a wet surface, so look for a sheltered spot that still allows you to see your subject. And watch out for splattering, which will make Pentel ink run.

Wind is rugged to contend with too. It's almost impossible to draw on a sketchpad that keeps moving up and down due to gusts of wind. I tried a sketch at a local airport on a windy May day and got some of the weirdest lines I've ever created! It looked like a drawing done by a very nervous person. Try to find a spot away from the wind.

Drawing in a moving vehicle will give you a similar effect, since your drawing surface won't remain stable.

Listen for a local weather report before you plan your trip out on location. It could save you a lot of grief.

One final comment about water. Be careful where you stand. I had a few drops from an overhead window airconditioner land on my drawing one hot summer's day, almost ruining the sketch. If you're standing next to a building, look up to see what's overhead.

SHIFTING YOUR POSITION

You don't have to be an absolute purist about drawing the scene in front of you just as it is. Don't be afraid to shift elements and your own position if it's to your advantage.

If there's some element in your composition that disturbs you, modify it. It could be a tree or a light pole that conflicts with some other part of the scene. Move it out of the way or eliminate it completely. Why not? You're the artist and you have every right to make all the changes you desire. You can make objects smaller or larger, lighter or darker, move them to the left or right, or take them out entirely.

Shifting your position, especially in the city, can do wonders for your composition. By moving around you can bring a lot more into your line of vision. Paul Hogarth, the splendid English artist, has been known to shift his position as many as four times in one drawing! If he can do it, so can you.

THOSE GOLDEN DRAWING DAYS

Once in a blue moon you'll have what I call a "golden drawing day." On a day such as this everything goes along perfectly. The subject matter turns you on so much you feel as though you could draw forever! Your hand may feel detached, as if it had a mind of its own, requiring no thought on your part to make it function. When this happens, take advantage of it and draw like the devil.

It is a strange and rewarding experience, and a little scary too!

Tree Stumps. *Pentel with wash and drybrush on 15" × 20" sketchpad paper. The stumps were boldly sketched in, then clear water was brushed over the ink areas to create the tones. An almost completely dry brush was used to develop the texture on the sunlit side.*

BIBLIOGRAPHY

Brandt, R. *The Artist's Sketchbook and Its Uses.* New York, Reinhold.

Cooke, H. L., and Dean, J. D. *Eyewitness to Space.* New York: Harry Abrams, 1971.

DeReyna, Rudy. *How to Draw What You See.* New York: Watson-Guptill, and London: Pitman Publishing, 1972.

Fawcett, Robert. *On the Art of Drawing.* New York: Watson-Guptill, 1964.

Kaupelis, Robert. *Learning to Draw.* New York: Watson-Guptill, 1966.

Kemper, Alfred. *Drawings by American Architects.* New York: Wiley, 1973.

Kent, Norman. *Drawings by American Artists.* Santa Cruz, California: Bonanza.

Meglin, Nick. *On-the-Spot Drawing.* New York: Watson-Guptil, 1969.

Troisé, Emil, and Port, Otis. *Painting with Markers.* New York: Watson-Guptill, and London: Pitman Publishing, 1972.

INDEX

Edited by Margit Malmstrom
Designed by James Craig and Robert Fillie
Set in 10 point Optima by Gerard Associates/Graphic Arts, Inc.
Printed and bound by Halliday Lithograph Corp.
Color Printed by Algen Press Corp.